1974

SCULPTURE in CERAMIC

SCULPTURE in CERAMIC

BY FRED MEYER

WATSON-GUPTILL PUBLICATIONS/NEW YORK

Published by Watson-Guptill Publications,
a division of Billboard Publications, Inc.,
165 West 46 Street, New York, N.Y.
Manufactured in Japan
ISBN 0-8230-4694-X
Library of Congress Catalog Card Number: 79-152753

Contents

Introduction

The ceramic sculptor and the potter can be the same man. And it is sometimes difficult to distinguish between a piece of sculpture and a ceramic pot; that is, if you should wish to. After all, nicely sculpted swans can also hold gravy, and a head of Falstaff can also be a tankard of beer. Who is to say whether this is sculpture or pottery? There are other things more interesting to think about; you should not worry over the distinction.

Yet since I have written a book about sculpture in ceramic, I should tell you that you will not find much about plates, cups, bowls, vases, and so on, even though such things can have sculptural characteristics. My book has limited itself to ceramic sculpture that is basically nonutile—impractical—and attempts to be beautiful without the necessity of holding flowers, cookies, incense, or tea.

I have also emphasized terracotta, the generally unglazed, yet often painted medium, although I have discussed glazed ceramic and have also touched upon porcelain, the elegant form.

Sculpture in ceramic is an old art with a 7000-year history. The nature of man's many cultures—his current image—is reflected in his shaping of clay, dug pretty much from beneath his feet.

Ceramic sculpture is a modern art, too. The directness of expression which is so much a part of clay is in keeping with our present impudence, our disinterest in working for "posterity," and our desire to "live for the moment." The several stages required to arrive at a finished bronze, for example, are avoided in the single-step firing process of clay.

However, the essential nature of the clay is its nicest modernity. In an age of complexity, it is both pleasant and perhaps even requisite to return to the fundamentals. The four primordial elements—fire, water, earth, and air—are involved in the creation of ceramic sculpture in a quite pure and direct way.

A sculptor takes earth and mixes it with water and then fires it with the right proportion of oxygen and—if he is at all inspired—produces something which possesses a genuineness which is always evident. In the face of mechanization, mass production, and dehumanizing intricacy, a lone fellow can still do something singular without too much bother.

For such reasons I make ceramic sculpture. Now I have written about it—its history, approaches, and technique—for I believe this art form deserves its fair share of adherents in our age.

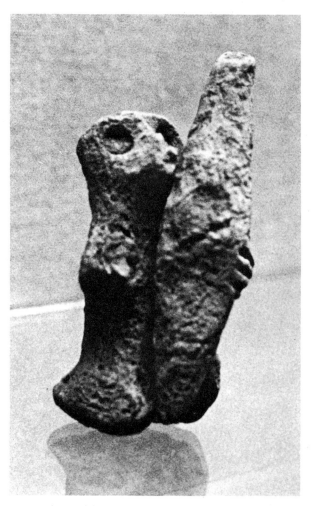

A Monkey with Fruit. Pre-dynastic Egypt. Collection
Royal Ontario Museum, Toronto.

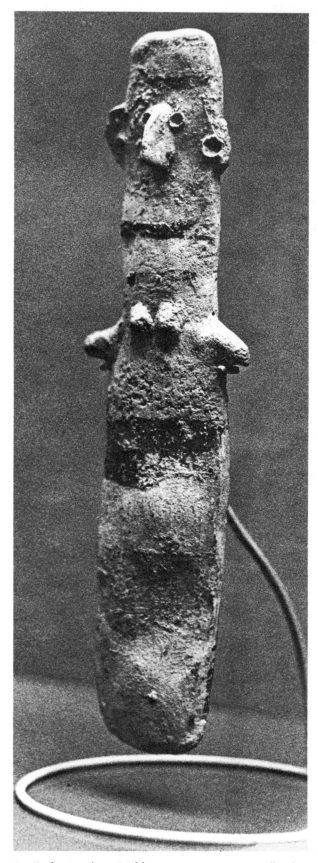

An Early Cypriote Goddess. 3000-2000 B.C. Collection
Royal Ontario Museum, Toronto.

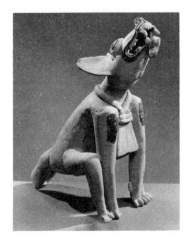

CHAPTER ONE

An Opinionated Historical Tour

Every guide has his favorite sights and his favorite roadways and alleys, and once you submit yourself to such a fellow, you also open yourself to his prejudices.

Thousands of tourists willingly enroll themselves in escorted tours; they welcome the simplification such tours bring. How many travelers to Rome, for example, are willing to explore it without aid? The place is too foreign, its surface too hectic, its pleasures too hidden, its treasures too rich.

A guide provides sense. Out of the jumble of galleries, museums, of piazzas, of villas; out of the nightclubs, hotels, restaurants, he chooses and selects. Should the guide be blessed with good taste, be a bit eccentric (yet not so eccentric that he bypasses St. Peter's Square, the Spanish Steps, or the Baths of Caracalla), he can provide the tourist with a much better experience than would have been possible if the tourist had struck out on his own.

The same is true with the world of ceramic sculpture: it is a big scene. Ceramic sculpture centers around the oldest sculptural medium, clay, which is still being used. Every culture has worked in it, been embellished by it, and has stamped the clay with its moods.

If you will allow me the status of guide, and bear with my high-handedness, I would like to take you on a charted tour. It will consist of a great many of my "favorites," but I hope will convey a sense of ceramic sculpture's scope, style, and techniques.

ANCIENT CIVILIZATIONS

Clay is the oldest sculptural medium. Man has been working with it since the beginnings of history.

A Monkey with Fruit. This little baked mud monkey, only about 3″ high was made in predynastic Egypt, before 3000 B.C. To me this monkey seems to be holding not the usual fruit, but a tiny loaf of French bread. His winsomeness is not unlike that of trolls, whom my daughter finds bewitching. Being over 5000 years old, it is certainly one of the most intimate contacts we have with the forebearers of the Fertile Crescent.

An Early Cypriote Goddess. The Earth Goddess was always a favorite theme of the earliest sculptors; her images often served as focal points for cults. The female nude, with innocent emphasis

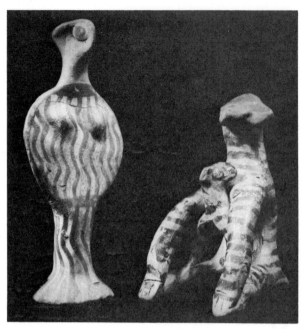

Two Mycenaean Females. 1400 B.C. Courtesy Bernard Danenberg Galleries, Inc., New York (Photo, Nathan Rubin).

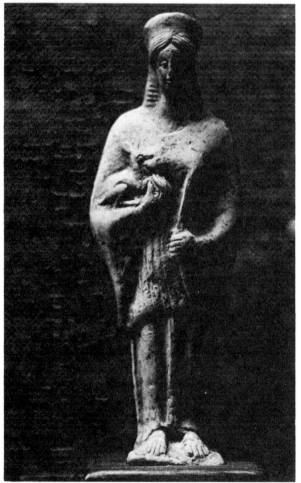

Demeter with a Rabbit. 700 B.C. Collection Royal Ontario Museum, Toronto.

upon breasts and delta, symbolized fertility, and her fertility related to that of the soil.

Yet how demure the small breasts of this Semitic-nosed woman appear. How stoic her face seems when compared, for example, with the voluptuousness of the Willendorf Venus, the archetype of the Earth Mother from the time of the Upper Paleolithic.

Two Mycenaean Females. These pieces of warm tan terracotta painted in red were made in Mycenae in 1400 B.C. The figure on the left is typical enough of the period. But I am fascinated by the rather more casual position on the right; the woman seems to be looking quizzically down upon a dog, harbored between her legs. Yet I could be mistaken.

Demeter with a Rabbit. This piece is also only 3" high, yet look at the careful detailing in the feveret (a hare in its first year), the hands, feet, and the face! The figure is of Demeter, Grecian goddess of the underworld, in her capacity as Earth Mother; the hare is a sign of her reproductive power. To ward off her foes, the underworld's evil spirits, images of Demeter were placed in tombs.

Clays of this type were made in the Ionian cities and show Oriental influences; some forms were derived from Egyptian coffin sculpture, by way of Phoenician copies. Certainly the head and the simplicity of the robing suggest the Egyptian influence. Here, too, for the first time, we see a piece cast from a mould. The monkey, the Cypriote Goddess, and the Mycenaean work were fashioned by hand. They were one of a kind. The Mycenaean females were handled, in fact, in a manner which is much admired today—directly and spontaneously. Simple pinchings created a face; the bodies were made by rolling and pressing, and the quick shaping of coils. Here, however, because the statuettes were popular and figured in trade, they were produced in quantity with moulds.

At this time, the moulds were one piece, and the entire front of the image was done at one time. The mould was baked as hard as was possible, and the *koroplast*, or maker, pressed wet clay in this. As the clay dried, it separated from the mould. The *koroplast* then cleaned the casting and sharpened its details with tools. The back of the piece was usually formed with less

finesse, and only seemed to complete the cylin-drical shape.

A Quiet Dionysus. Can this be the god of wine who reigned over the Dionysiac revels and who later became the roisterous Bacchus of the Romans? He holds his *kantharos*, or wine cup, which is certainly of a moderate size. To party-goers I suspect his look of pensiveness could seem deflating.

This Dionysus was cast (from a one-piece mould) about 600-500 B.C. In that age, perhaps he could afford to remind his followers that un-restrained bacchanalia only ends in hangover and ennui. And yet there is a fullness to his lips, a bit of a smirk, which suggests his later succumbing.

A Sicilian Aphrodite. I met a *principessa* in a *pensione* on the Via Veneto in Rome in 1955—when you could still stay in *pensioni* on the Via Veneto without paying grand sums. After some hedging, she confessed to her indigence and asked me to lend her enough for back rent, so that she wouldn't be put out into the street. This discussion was held at a cafe and handled—on her part at least—with the greatest aplomb. The amount she owed, however, was large.

She took a red box from a net sack and opened it. It was this Aphrodite, set within red velvet, and she said, "I will give you this, as security. It is my dearest possession." She made a little motion over its surface, with long, thin fingers that were now old. "This body, it is like mine. Like mine used to be." I provided the lire; yet I never saw her again.

The statuette is Sicilian, made in the second century B.C. By this time, the Greeks had re-fined and complicated their production. Each figure now required not just a single mould for its casting, but a great many. Separate moulds were used for heads, arms, and legs. Little fans, birds, and mirrors were also cast and later added to some of the figures. What is more, the moulds were used interchangeably and a large variety of statuettes were thus put together. (As a result, some heads seem too small for bodies, and vice versa.) After they had been fired, the works were coated with lime-wash and then brightly painted. Since the lime-wash peels readily, most of the paint has come off.

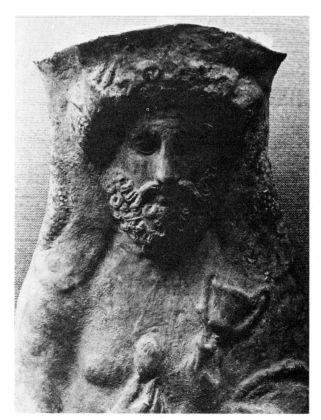

A Quiet Dionysus. 600-500 B.C. Collection Royal Onta-rio Museum, Toronto.

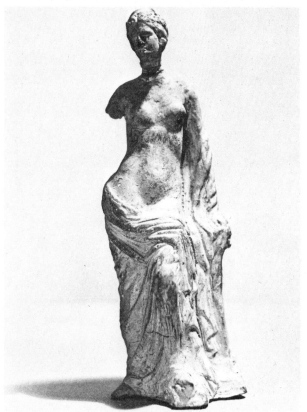

A Sicilian Aphrodite. 200-100 B.C. Collection of the author.

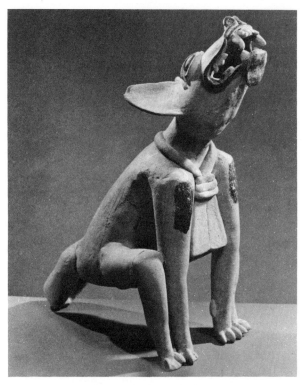

A Mexican Coyote. Pre-Columbian. Courtesy Museum of Primitive Art, New York.

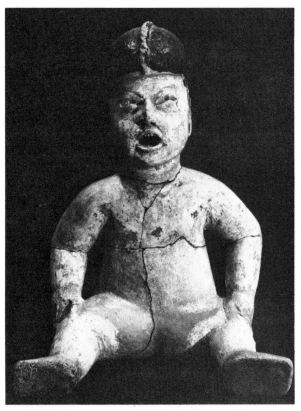

An Olmec Baby Face. 500 B.C.-1150 A.D. Courtesy Bernard Danenberg Galleries, Inc., New York (Photo, Nathan Rubin).

My Aphrodite has somewhat split down a side, suggesting that this was one of the places where the separate castings were attached. Some inept person glued the statuette's head back in a crude way; so, too, with the nose, and yet she is still a beautiful woman. She is 2000 years old, and although much of the time was probably spent in a burial place, I like to think that some hundred generations have cared for this fragile, low-fire bisque terracotta and handed it on.

A Mexican Coyote. This strong, pre-Columbian ceramic was made in Veracruz, in the province of Remojadas; its body is hollow and thin; the clay is an orangish color. It is largely handmade, although some of the details, such as the teeth, could be *pastillage* (formed separately in a mould and inserted into the piece). Such refined and powerful primitivism as this is still found in the work of the contemporary Mexican painter Rufino Tamayo.

An Olmec Baby Face. The remarkable thing about the Olmec sculpture is its facial sophistication, although it was made near Tres Zapotes, along the Mexican Gulf Coast, in prehistoric times! Not much is known about the Olmec people: no ties have been found between them and another ancient civilization. These standardized figurines, cast in moulds, are hollow; each has a half-opened mouth, some showing their tongues, others sharp teeth. These ancient faces with their Oriental eyes are all that remain of this forgotten race. Like the famous child of World War II, photographed in a bombed railway station, they, left behind, also seem to cry out their anguish.

Sarcofago degli Sposi. Just as I believe that Giotto's frescoes in the Scrovegni Chapel in Padua are the greatest manifestation of painting, and the Brandenburg Concertos of Johann Sebastian Bach stand as the greatest accomplishment in music, so, too, I believe that this *Sarcophagus of the Married Couple* is the Western world's greatest piece of sculpture—bar none. That includes bronzes—all of them. And it was done in terracotta! It is Etruscan and was built in the second half of the sixth century B.C. Carefully restored, with its patches done in a slightly different color of clay, it presently stands in the Museo di Villa Giulia, in the Borg-

hese Gardens, Rome. It is technically remarkable: for example, note the position and projection of the eloquent hands. For me, however, its magnificence rests in the tenderness of the relationship, even in death, between this man and his wife in their gentle, acknowledging smiles.

I could speak of the subtlety of the balancing between the open, large areas and the areas of detail, the nuances of soft versus hard shadow, and the delicacy of the line. But all of this pales—as it should in great art—in the face of the strength of the revelation. Yes, death can be sweet, or at least be made tolerable; the love of a man and a wife can transcend it.

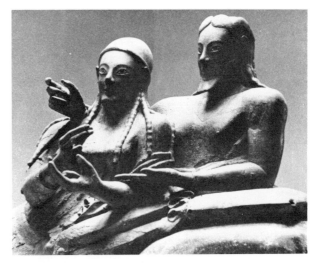

Sarcofago degli Sposi. 650-600 B.C. Collection Museo di Villa Guilia, Rome.

THE MING DYNASTY

The Ming Dynasty lasted from 1368 A.D. to 1644 A.D. Although its fame rests largely with its manufacture of nonpareil porcelain, I personally favor its charming low-fire terracotta, those genre objects and burial pieces.

Kuan Ti, God of War. This great piece of Ming Epoch stoneware was done in three colors—blue, yellow-gold, and green—with a lustrous overglaze; it stands more than six feet high and was fired in one piece. Here is our first look at high-fired sculpture. The Chinese carved their kilns into the sides of their hills; the walls encouraged high temperature, and the great tunnels provided vigorous draft.

The duality of Western thinking—the conflict between evil and good—is mocked here in the Buddha face of Kuan Ti. His smile betrays both contempt and compassion—the cruel and the benign—while his apparel displays both the dragon of death and the lotus of life. As a god, he has the right to encompass all, both the good and the bad, and this establishes oneness.

A Ming Compound. This compound, one of the treasures in the remarkable Oriental collection of the Royal Ontario Museum in Toronto, is in the *ming-ch'i* style. As all of the *ming-ch'i*, it was made to be entombed with the dead, in order that they would not lack the necessary comforts. The groom, you see, holds the deceased's horse at the ready. The servant stands waiting in the doorway. And, further within, the dog waits for the master.

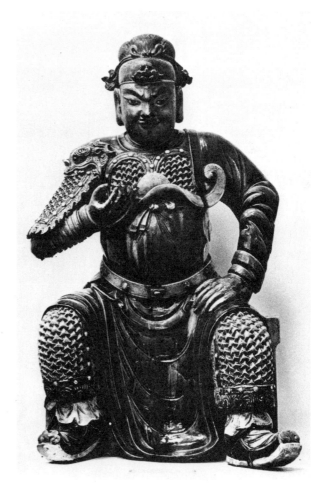

Kuan-Ti, God of War. Ming Dynasty. Collection Royal Ontario Museum, Toronto.

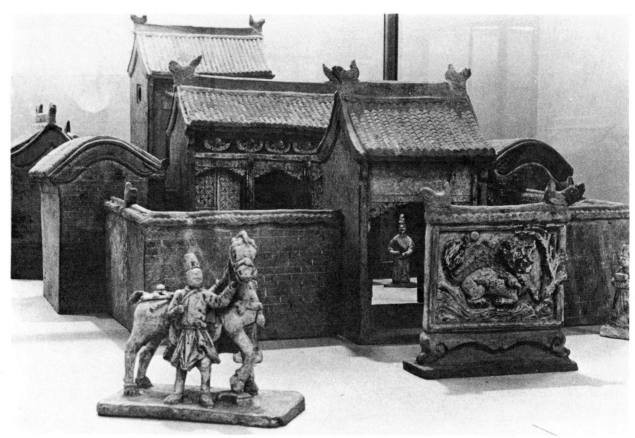

A Ming Compound. Ming Dynasty. Collection Royal Ontario Museum, Toronto.

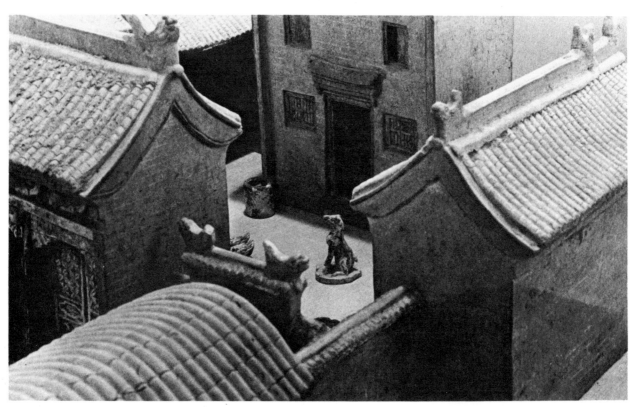

A Ming Compound. (Interior View)

A Ming-ch'i Cortege. Excavations in the cemetery at Ur have shown that the Sumerians, in the fourth millenium B.C., entombed the courts, still alive, together with their dead royalty. Skeletons of servants, soldiers of the guard, musicians, and ladies-in-waiting—some showing the remains of gold ceremonial regalia—sit composedly in rows, as if they had perhaps taken a poison after accepting burial with their king.

The Chinese, too, are suspected of burying courts together with monarchs. But later (could there have been a servant problem?), they took to burying the terracotta *ming-ch'i* surrogate figures instead.

As a result, we have this glorious pageant. This burial group is from the Northern Wei Dynasty, done in A.D. 525, and taken from the tombs of the ruling house of the Toba Tartars, near Lo-yang. The pieces are cast and hollow. The clay is grayish tan; you can see traces of paint both white and cinnamon red.

The dead ruler, I would say, entombed with such a cortege as this, should indeed be content: he has his horses, soldiers, great giant guards, his ladies, his covered cart, chickens, sheep, his camel, and even a good-humored Sphinx.

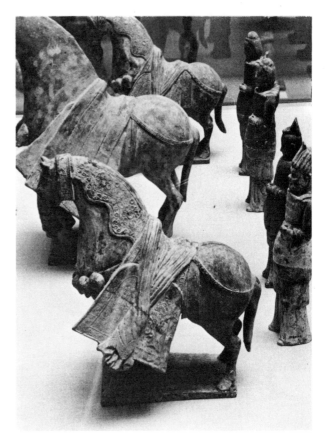

A Ming-ch'i Cortege. (Detail). 525 A.D. Collection Royal Ontario Museum, Toronto.

THE ATELIER DELLA ROBBIA

Luca della Robbia, born in 1400, was trained as a goldsmith, but first established himself as a sculptor with his marble bas-relief of singing boys on the tribune of the organ in the church of Santa Maria del Fiore in Florence. He became disenchanted, however, with the laboriousness of chipping and chiseling marble, and, after considering bronze, found himself annoyed with the several-stage method of casting. (The sculptor in bronze moves from clay to plaster to wax to bronze; he often loses detail and suffers botchings at each of the transitions.)

Luca had always—as did all of the sculptors of the period—worked up a clay model before doing his marbles. He decided, therefore, to render the clay sufficiently durable to live its own life, and not merely act as a maquette for a final piece in another material. He baked a clay model to a temperature high enough to turn it to stoneware and then covered it with a vitreous coating, an enamel of tin and of lead.

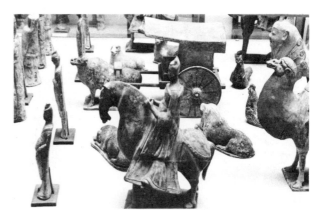

A Ming-ch'i Cortege. 525 A.D. Collection Royal Ontario Museum, Toronto.

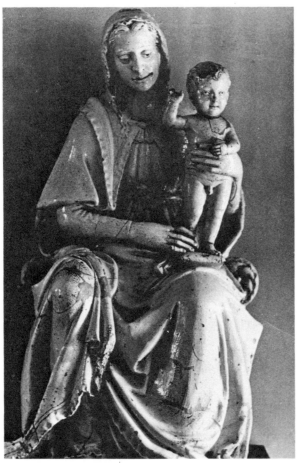

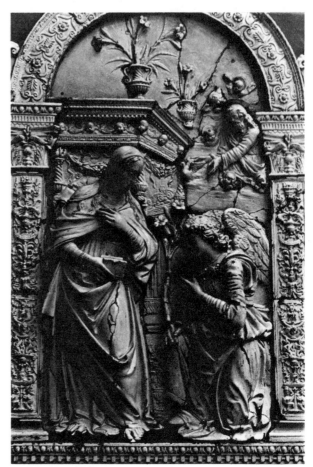

Virgin and Child. *c. 1535. From the Atelier della Robbia. Collection Musee de Céramique, Sèvres, France.*

The Annunciation. *c. 1535. From the Atelier della Robbia. Collection Victoria and Albert Museum, London.*

Cafe Cherubs. *c. 1900. Found in the Piazza San Michele, Lucca, Italy.*

By about 1438, Luca had found his medium; the clay was relatively quick to work with, and his hot oven and white coatings made it nearly impervious to the weather. What is more, it was handsome.

Later, he complicated and flattered his white glaze with a lapis lazuli blue ground. Then he began to add greens, violets, browns, and yellows. After a life devoted to decorating Tuscan churches, he died in 1482 and left his trade and his techniques to his nephew.

Andrea, born in 1457, continued the tradition. His archivolt, soffit, and panel over the main doorway of the cathedral in Pistoia are grand examples of his ability.

In 1528, when Andrea died, three of his four sons—Giovanni, Girolamo, and Luca—continued to produce ceramic sculpture. Such works as the 7' high *Virgin and Child*, and *The Annunciation* came from their workshops.

Perhaps the most impressive production of the della Robbias is the facade of the Ospedale del Ceppo (The Hospital of the Tree Trunk) also in Pistoia. The work, a frieze representing the seven works of Mercy, was done by Giovanni della Robbia, assisted by Benedetto and Santi Buglioni; it is exquisitely glazed largely in white, orange, yellow, and blue polychrome upon a warm Venetian red terracotta.

It is especially interesting that the seventh (final) panel, done by Paladini in 1585, stands unglazed. This seems to prove that the secret of polychrome finish was lost with the passing of the della Robbia family.

I have spent long months working in a foundry in Pistoia. The Ospedale del Ceppo stands on a side street that always seems damp and never quite touched by the sun. The walls of the hospital are the peculiarly ugly and scaled acid ochre that one too often finds here; the rain has badly stained them. Little white trucks unload the sick on minimal stretchers, and they are carried in through the worn, wooden doors to what seems a forbidding interior. In a rough bar across the way, television blares and somber men sit about at rusted tin tables. The place sells lottery tickets. A bad restaurant with pseudo-sophisticated decor is found down the way, and behind it, the town's only whorehouse. Soldiers, stationed on the town's outskirts, mostly dressed in outsized uniforms, loiter about after having a cheap meal in a dim *trattoria* and before patronizing the whorehouse on their Saturday nights.

It is the worst part of town. There, above all this grimness, is a frieze which can well be the most beautiful in the whole of Italy. Yet I have never seen anyone look up at it—never.

THE RENAISSANCE: ITALIAN STREETS

During the Renaissance, Italian church and palace architects used a large amount of terracotta. To Brunelleschi and Bramante, fired clay was as respected a material as brick or stone. Michelangelo and Donatello, as well as the della Robbias, used it.

The exquisite Certosa di Pavia, considered by many to be the most beautiful structure of Renaissance Italy, was begun in 1396, finished about a century later, and uses much terracotta. The arches, capitals, and window trim of its Corte del Capitolo are of fired clay; so is its tile roof. The arches and cornices of its Great and Small Cloisters are red terracotta; the figures and portraits in the spandrels and in the friezes are terracotta as well. Their detail is still exceptionally sharp and clear, although the work is five centuries old.

Other remarkable terracottas can be found upon the Palazzo Municipale in Piacenza, the Palazzo Stanga in Cremona, and the Church of San Giacomo in Bologna.

The Ospedale Maggiore in Milan boasts a facade which, with the exception of its lower story columns, capitals, and sills, is exclusively of red terracotta. Its window architraves are especially rich: a composition of garlands, children, and grapes.

But you merely need to stroll through nearly any of the larger northern and central Italian towns to find buildings carrying terracotta. There are cornices, friezes, columns, archivolts, window trim, tombs, seals, plaques, reredos, and medallions, all of terracotta.

Yet instead of sculpted saints and heroes (here my eccentricity manifests itself), I prefer to show you a pair of glazed polychrome cherubs which I found upon a street in Lucca. The shop, now a pharmacy, wears several of them about its side and front. It was once, it appears, a cafe: the cherub to the right holds aloft a gleaming silver pot of coffee and a white, hexag-

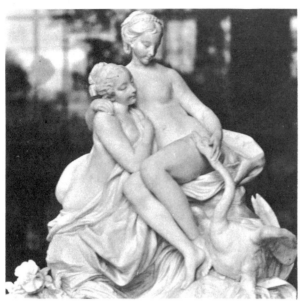

Porcelain Manufactured at Doccia, Italy. 1760. Collection Museo Poldi-Pezzoli, Milan.

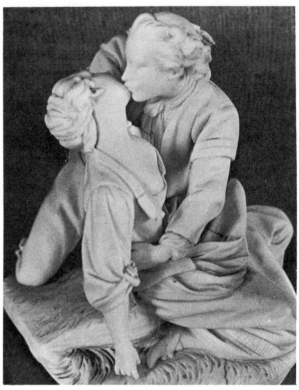

The Kiss. Duplesis, 1756-73. Collection Musee de Ceŕamique, Seỳres, France.

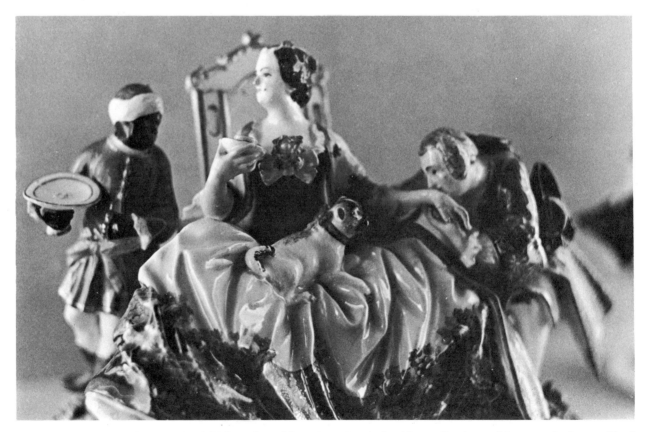

A Meissen Porcelain. 1700-1800. Schneider Collection, Schloss Jaǧerhof, Dusseldorf.

onal cup. They are perhaps no older than the turn of the century; the place bears evidence elsewhere of art nouveau touches. I enjoy the blond hair; their bodies are rubbery, pink, and bedimpled much like the New Year babies on covers of old *Saturday Evening Posts.*

THE EIGHTEENTH CENTURY:
A PORCELAIN PASSION

I have another weakness, and as your guide I expect your indulgence. That is the porcelain produced in Europe in the first part of the eighteenth century in Germany and France and, to a lesser extent, in Italy, Austria, and England.

For these few years, in this art of clay, the artists and artisans of the porcelain factories caught and distilled the essence of that grand epoch when *savoir-vivre* reigned. It was an epoch which led Talleyrand to say that no one who had not lived before 1789 could appreciate the pleasure of living.

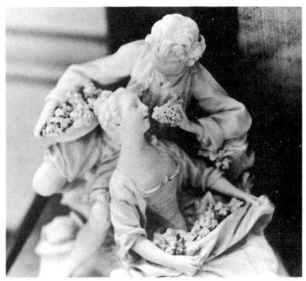

Porcelain Manufactured at Vincennes, France. Falconet after Boucher, 1740-56. Collection Musée de Céramique, Sèvres, France.

The Kiss. It was a time divorced from our own, a time which appears—in the light of the porcelains—so opposed to our own that you could say the opposition is quite diametric. Kisses are not this way anymore. Certainly blacks no longer wait on milady as portrayed in the Meissen porcelain pictured nearby; suitors no longer kneel at the feet of the object of their affection. Courtship—which presupposes hesitation—seems today to be nearly superfluous.

Lesbianism as expressed in the porcelain of the two voluptous females with a swan has lost any lyricism it might have had.

The sweetness of smile, the dimpled cheek, the coquetry of the lady with her swain have all vanished. The woman of today does not smile, at least not in the high-fashion magazines; the hollow cheek seems more in vogue than the dimple, and the new matter-of-factness has sent coquetry fleeing.

Today the cock-of-the-walk (shown seated at the writing desk), the dandy, the periwigged gallant, would embarrass us with his effeteness. He is liable to mince; he postures. Today, instead, a man strides or lounges, and the mistake is to reveal the state of one's heart.

Nor do we surround ourselves with rare birds. There aren't too many anymore. Besides, what

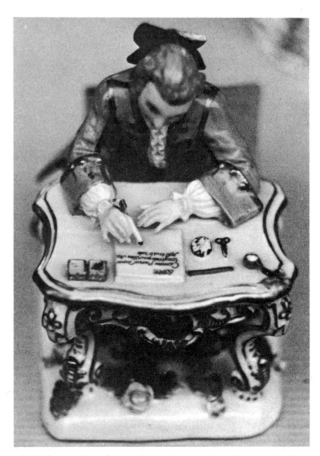

A Meissen Porcelain. 1700-1800. Schneider Collection, Schloss Jägerhof, Dusseldorf.

La Danse du Chien Savant. *Falconet after Boucher, 1793. Collection Musee de Ceŕamique, Seẁres, France.*

self-respecting military man would allow a cockatoo to perch on his shoulder?

So when I wish to escape from the present, to get as far away from it as I can, I find no better way than to visit cases of eighteenth century porcelain. There reside gentility and graciousness—little oases of contradiction, mostly in the centers of frenetic, crass cities.

THE PORCELAIN SECRET FORMULA

The beauty of the porcelain figurine is due in large part to the whiteness of the clay from which it is made. The transparent glazes with which it is painted can only gleam and be as rich as they are if the clay body is pure white and reflective.

The Chinese knew how to make hard, thin, beautifully translucent porcelain from 900 A.D. (Kaolin and petuntse, two essential ingredients, were mined in the province of Fukien.) Yet they guarded their secret well.

The identity of the originator of true European porcelain is somewhat in doubt. The earlier efforts of John Dwight in Fulham, England, had nearly succeeded, yet he failed to incorporate petuntse into his formula. In 1694, Louis Poterat produced a soft-paste porcelain in France. Most authorities attribute to Johann Friedrich Böttger the achievement of a porcelain comparable to the Chinese. Others claim, however, that the actual discoverer was Ehrenfried Walther, the Graf von Tschirnhaus, a chemist who was Böttger's superior in the pottery at Dresden.

Fascinating intrigues have been played out around the porcelain recipe. There is the story of Père d'Entrecolles, a French Jesuit missionary, wheedling the composition of the secret formula from his Chinese converts (some anticlericals say in exchange for indulgences) and spiriting the information out of China to Paris, thus enabling the French to establish their famous porcelain factory at Sèvres.

Another story tells of Böttger's folly: despite the fact that he had confided the secret to only two persons, and under blood oath, he caused the recipe to be leaked to the Austrians. It seems that Böttger, a man of certain weaknesses had recited—or rather sung—the secret during a drinking bout. His drinking companion, Christoph Konrad Hunger, apparently not hazy

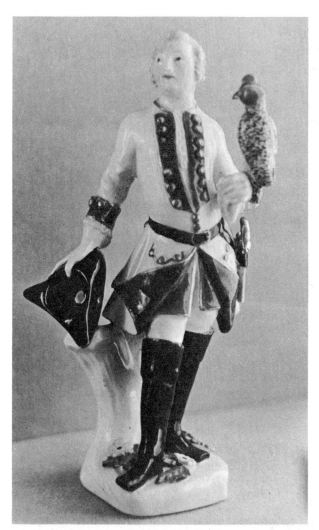

A Meissen Porcelain. 1700-1800. Schneider Collection, Schloss Jägerhof, Dusseldorf.

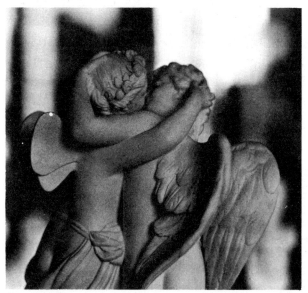

The Kissing Cupids. Contemporary casting from earlier moulds. Musee de Ceramique, Sevres, France.

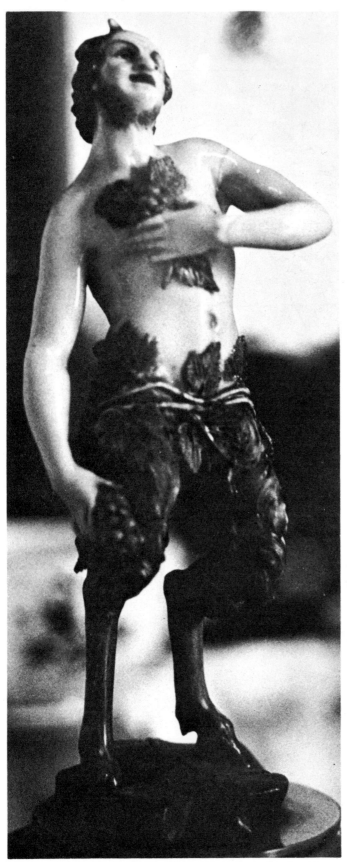

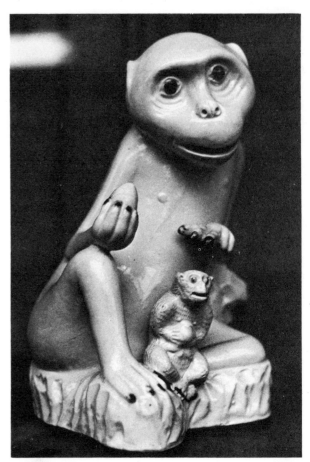

Monkeys. *c. 1740. Collection Victoria and Albert Museum, London.*

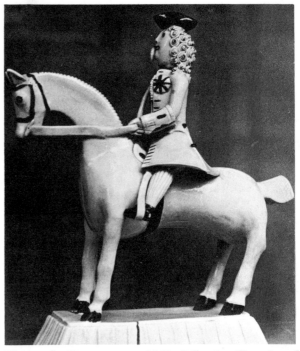

A Capodimonte Porcelain. 1700-1800. Collection Museo Poldi-Pezzoli, Milan.

Figure of a Horseman. *c. 1740. Collection Victoria and Albert Museum, London.*

enough to ignore the significance of the recitation, carried it to Vienna (for a price) in 1717. Yet perhaps he *had* garbled it somewhat, for the Viennese had to purchase the defection of the Meissen kiln-master in 1719 to give them more help in the matter.

By 1719, the Viennese were producing true porcelain. However, they were somewhat interrupted when the Meissen kiln-master—being, it seemed, both homesick and regretful—polluted the factory's raw materials and skipped back to Dresden in the shadow of night.

The Sèvres factory, which opened in 1756, (the operation moving from Vincennes) soon took the lead in porcelain manufacturing, partly because Meissen had been taken by the Prussians during the Seven Years' War.

Here the emphasis was Rococo instead of Baroque (see *La Danse du Chien Savant*) in the tradition of Vincennes. Later, however, the chemists at Sèvres improved the *gros bleu* underglaze of Vincennes to the stronger, deep *bleu-de-Roi* and made other changes in glazes. The Sèvres factory continued to work in soft-paste, partially because their unglazed biscuit seemed to successfully imitate marble, and partly because a good French kaolin was not found until 1768 at Limoges.

The Sèvres factory—Manufacture Nationale de Sèvres—is still operating in the back buildings of the Museé de Cerámique in the center of Sèvres. *The Kissing Cupids* are made from a contemporary casting from an earlier set of moulds. It can be purchased there for 1,230 new francs.

In 1743, Charles of Bourbon, King of Naples, set up a porcelain factory at Capodimonte. The Capodimonte figurines in translucent soft-paste are distinguished by the subdued tonality of the colors; these are mostly deep greens and rich browns. In 1759, the King took the Capodimonte factory with him—lock, stock, and barrel—to Spain.

The English did not begin to produce a good porcelain until 1750. Some of the finest examples came from the potteries in Staffordshire, where William Littler and his wife Jane succeeded in producing figurines.

I personally prefer this earlier salt-glazed stoneware from Staffordshire. I like the primitivism of it. The *Monkeys* and the *Figure of a Horseman*, made around 1740, are particularly fetching examples.

I wonder why both the English monkey and the Grecian Dionysus hold an egg in their left hands!

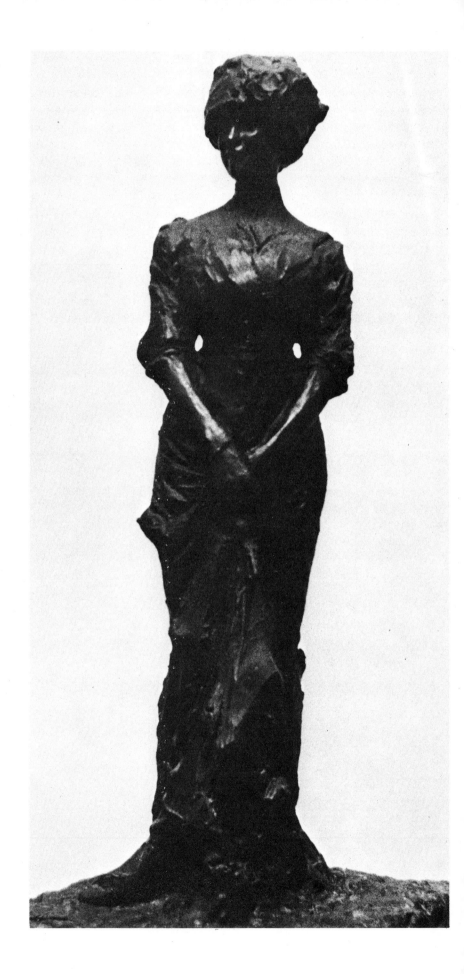

Mia Moglie. *Paolo Troubetz-*
koy. 1911, Bronze. Collec-
tion Galleria Nazionale d'Arte
Moderna, Rome.

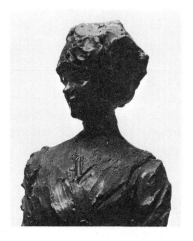

CHAPTER TWO

More Recent Ceramic Sculpture

Many important sculptors have used clay as a secondary material. I do not mean plastiline, which is an oil based clay, generally greenish-gray in color, and reusable; plastiline is a material that such turn-of-the-century sculptors as Carl Milles preferred. Rather, I am speaking about water based terracotta.

Auguste Rodin, for example, did preliminary studies for his great figure of Honoré de Balzac—now in the collection of the Museum of Modern Art, New York—in terracotta. A fine facial study is owned by the Musée du Louvre.

Giovanni Bernini did his sketch, or maquette, of Pope Alexander VII, for the pope's tomb in St. Peter's, in terracotta. The French sculptor Pierre-Jean David sculptured the model for the projected monument to the poet Nicolas Joseph Laurent Gilbert in terracotta; the maquette for the monument to John, Duke of Argyll by François Roubiliac—now in Westminister Abbey—was first modeled in clay, etc.

MODERN ITALIANS: TROUBETZKOY, MARTINI

When doing their bronzes, today's Italians make good use of clay. When I am working at my Italian foundry, I build full size in wet clay, over wood and metal armatures. The only trick is to keep the clay damp, so that it doesn't crack apart on the armature; I keep the work wrapped in plastic and swathed in wet burlap. The clay is brought to my workshop once or twice each week by a cart and horse; the large, moist cubes are piled on metal sheeting off in a corner. It scents the whole place with its earthy, rich fragrance.

When I have completed a sculpture in clay, I have it cast into plaster by *formatori*. These are two young men who usually come from Pietrasanta and look like basketball players at a Y.M.C.A., but they work swiftly and surely and cast 10' figures in a single day. From the plaster, the piece is turned to wax, and from the wax state to bronze. I refine each of the stages to strengthen detail and to correct mutings that occur in casting.

The procedures of each of the towering contemporaries—Manzù, Greco, Martini—include the potter's clay. Upon occasion, though, they skip the clay stage and work directly in plaster. The great doors which have recently been installed in the Cathedral at Orvieto were first sculptured in clay by Greco. The poignant and beautiful *Door of Death*, done for one of the five porches

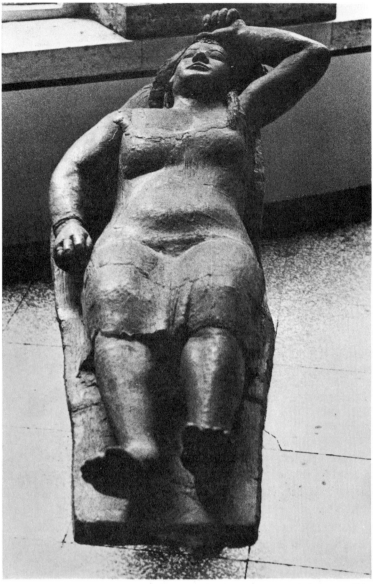

La Dormente. (Front View). Arturo Martini, 1929, life-size terracotta. Collection Galleria Nazionale d'Arte Moderna, Rome.

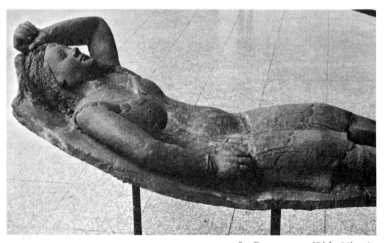

La Dormente. (Side View).

leading from the atrium to the inside of St. Peter's Cathedral, was obviously formed in clay by Giacomo Manzù, with the gentle encouragement (and later the strength of the memory) of Pope John XXIII.

Paolo Troubetzkoy, an earlier Italian sculptor who had a very strong influence upon Manzu, had obviously used clay for the first stage of his sculpture, *Mia Moglie*, done in 1911. When you look at the piece closely (see detail), the spontaneous and certain marks of his fingers—especially the single gouges to form the neck of the woman's dress, the several scrapes to suggest the puffs of the sleeves, and the smears to effect a satin bosom—could only be done in wet clay.

Troubetzkoy was smart enough to keep the clay's characteristics intact through the succeeding operations. It is, of course, possible to smooth away the irregularities of clay when a piece is in its plaster stage, thus moderating the spontaneity.

Certain moderns have used clay as a primary material. Some, like Picasso, have done so rather flippantly, without bothering to experience it fully. The vases and sculpture that Picasso has done, for example, were originally thrown on a potter's wheel by another. Picasso only sat to a side and, accepting the pieces as they were thrown, bent them here and there, then later brushed on some paint. But what bending and painting!

Other modern painters and sculptors have taken the clay of the potter more seriously, however. Without a doubt, the contemporary Italian who was most taken with the material was Arturo Martini (1889-1947). He obviously loved terracotta more than bronze: he worked for most of his creative life in the former.

His *La Dormente* is a splendid example not only of his humanism, but also of his technical mastery. The sculpture, fired in one piece, is life-size. It is raw sienna in color, as if the clay came from Siena itself. The clay is left as it came from the ground and later the kiln; Martini seldom liked to use glaze.

At times he mixed a good deal of grog into his clay. This gave certain of his sculptures, such as his *Il Pastore*, a roughened appearance. This figure, too, although more than 8' high, was built and fired in a single piece.

Less grandiosely, Martini did the little *Due*

Amanti, which is also unglazed and stands no more than a foot high.

His *Donna alla Finestra.* is also small, again about 12″ to 14″ high. Martini had been recurrently interested in interiors. One of his most beautiful works, done in 1931, is *The Dream*. As in *Donna alla Finestra*, he sculpts the mysteries of a woman indoors, conscious of that which is outside.

Other Italians—such as Leonardi, Genuto, Amendola, and Fabbri—have used clay as a final material. Lucio Fontana, after firing *Busto Femminile*, painted this piece with strong white and gold paint.

CONTEMPORARY CATALAN: JOAN MIRÒ

Unlike Picasso, who I believe has remained an inspired dilettante in clay, Joan Mirò, the Catalan painter, has taken it more seriously and explored it more deeply. He did his first work in ceramics in Barcelona in 1944 (Picasso did his first pots in Vallauris in 1950), collaborating with the potter Joseph Llorens Artigas. Like Picasso, Mirò at this time only decorated plaques that Artigas prepared; later, however, he worked in the clay with his own hands.

Artigas, like Mirò, espoused the natural in art. He built his own kilns—neither gas nor electric; instead he cut his own wood for fire. He developed his own clays and his own glazes. Mirò, a great admirer of the Catalan architect Antonio Gaudì, had always been especially taken with this great man's designs in the Municipal Park at Guell, and also his church, the bizarre and wonderful Templo Expiatorio de la Sagrada Familia in Barcelona.

Therefore, when Mirò touched ceramic clay—clay sympathetically prepared by Artigas—he could and did treat it much as Gaudì had treated the walls and stairways of his Park: he featured the rough naturalness of the clay just as Gaudì had done with his cements, and he used spots of glaze just as Gaudì had used broken crockery and glass.

Of course, Mirò also used a distillation of the forms and linear details that he had developed from his many years at his easel. *Personnage* is a fine example of Mirò's ceramics.

Mirò has spoken of his fondness for the ceramic technique and his awe of it too. He has

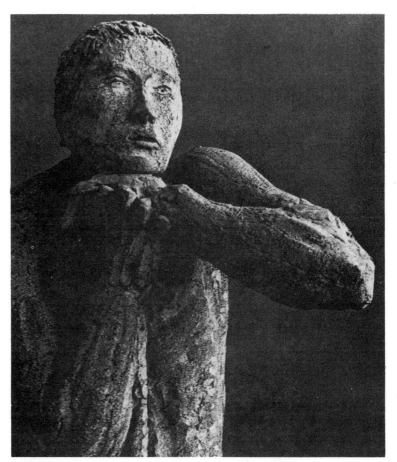

Il Pastore. Arturo Martini, c. 1925. Collection Galleria Nazionale d'Arte Moderna, Rome.

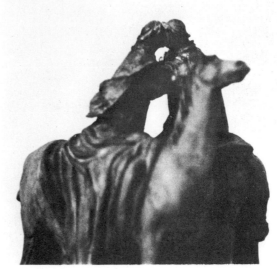

Due Amanti. Arturo Martini, c. 1930. Collection Galleria d'Arte Moderna, Milan.

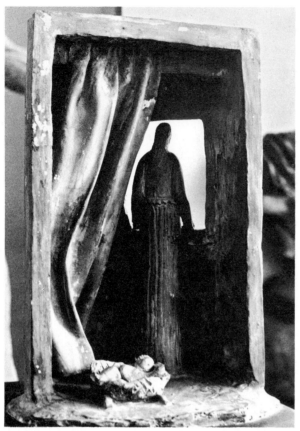

Donna alla Finestra. Arturo Martini, 1931. Collection Galleria d'Arte Moderna, Milan.

Personnage. Joan Mirò, 1955. Courtesy Perls Gallery, New York.

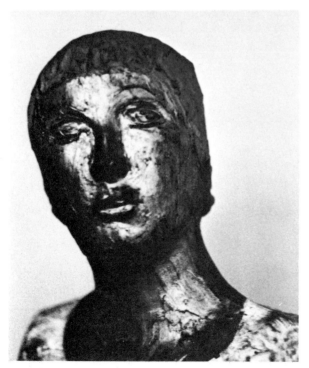

Busto Femminile. Lucio Fontana, c. 1931. Collection Galleria d'Arte Moderna, Milan.

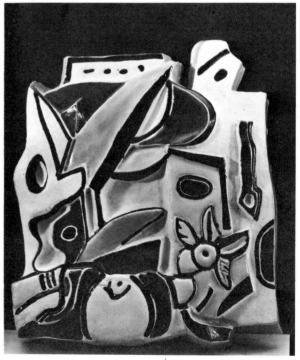

La Pomme Jaune. Fernand Leger, 1951. Courtesy Perls Gallery, New York.

said that in spite of every effort, the real master of the art is not the sculptor but the flame. What it does is unpredictable; a few degrees of shift can cause major changes. The fire is formidable; the artist must both revere and dread it.

MODERN FRENCHMAN: FERNAND LÉGER

In 1949, at Biot, a village in the Alpes Maritimes Roland Brice, a former student, put his kilns at the disposal of his teacher, the contemporary French painter Fernand Léger. It was then that Léger began to work in ceramic.

The painting of Léger is bold and straightforward, much like the man. Léger liked simple places, strong and basic pleasures, and the company of farmers, laborers, and knaves. His painting moves toward the elimination of all fuzziness or daintiness. He uses basic primary color and black and white, combined with bold shapes.

His work in clay, like his painting, is unequivocating and powerful. The colors are pure and primary. The shapes are even firmer than those in his canvases, for they are carved out from the clay in hard, protruding edges, and the pigment is cut in the manner of a signwriter. The overglaze is clear and high gloss.

Both his *La Femme au Pot de Fleurs* and his *La Pomme Jaune* were done in 1951. The two are small, the latter 11 1/8″ x 9 5/8″.

CONTEMPORARY AMERICAN: WILLIAM KING

Among the better-known American sculptors, William King is a favorite of mine. I like the quality of his work. He owes much to Elie Nadelman, an interesting sculptor who enriched American art in the twenties and thirties. By his later experimentation with sewn plastic and other modern materials, King has transcended the influence and done highly original work.

King has always liked terracotta. In his *Portrait*, done in 1957, he leaves the clay quite rough and loads on a great deal of thick glaze. The *Kitty*, done in 1956, like the *Portrait* is 18″ high and also has a white overglaze; I wouldn't know whether it cracked in the kiln, or later; I expect King wouldn't much care.

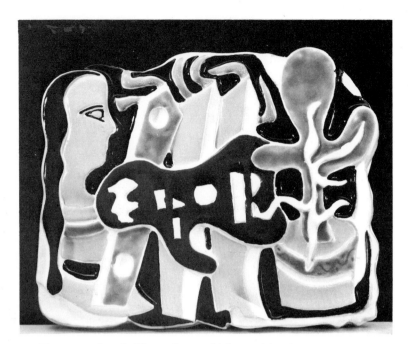

La Femme au Pot de Fleurs. Fernand Léger, 1951. Courtesy Perls Gallery, New York.

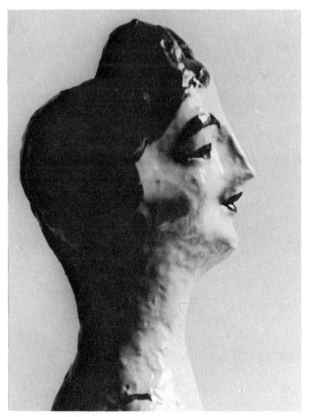

Portrait. William King. 1957. Courtesy Terry Dintenfass, Inc., New York.

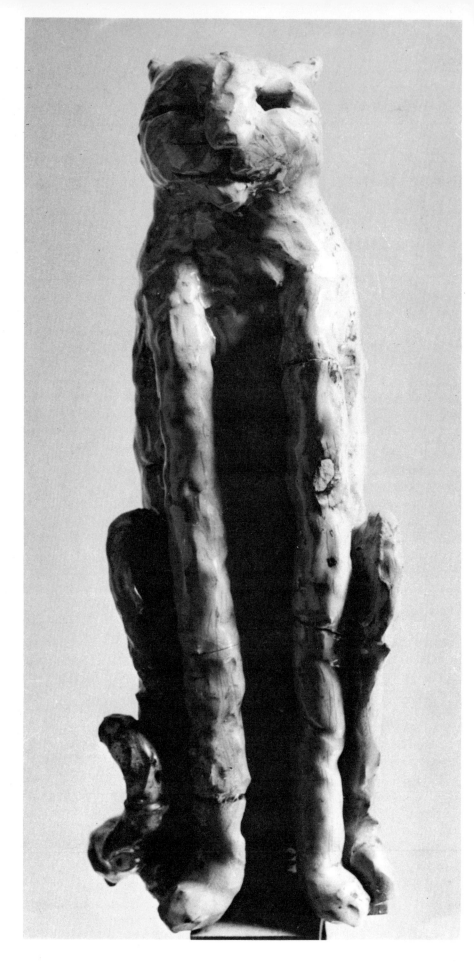

Kitty. William King, 1956. Courtesy Terry Dintenfass, Inc., New York.

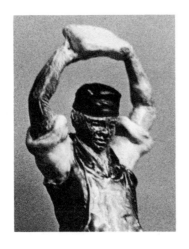

CHAPTER THREE

Clay

Clay is lovely stuff—once you come to terms with it. It is the result of the weathering of the earth's rocky surface. By submitting it to water and fire, we restore it to a measure of its once masculine hardness.

There is plenty of clay. We have far from depleted the supply. It is reassuring to realize that the pits at Amarousi (the source of the red clay used in Attic vases) and the excavations at Ludwigsburg (source of the kaolin that gave us our German porcelain) are both still yielding.

PRIMARY AND SECONDARY CLAYS

The ceramic sculptor knows both *primary* and *secondary* clays. A primary clay—china clay being the most obvious example, and there aren't too many of these—simply has remained where it decomposed. Or it has traveled so little that not less than half of its body is pure clay; the remainder is iron, mica, sand, and organic material. Secondary clays—which also decompose from igneous rocks as do the primary—have been carried by rivers away from their place of origin. Because of their journeys, perhaps—like the well travelled person—they have come to possess greater complexity. They are richer in many respects, more pliable and plastic than primary clays. Yet the purity is missing.

Secondary clays (the ball and stoneware varieties) can be black, red, pink, or creamish, depending upon what they pick up on their travels. The blackness is caused by a strong amount of vegetable matter; this is burned away in the firing, leaving the surface much lighter. Redness is due to a prevalence of iron.

One of the fascinations of the ceramic medium is the opportunity it gives you to mix clays from various places, in varying proportions, and—when you are lucky—to come upon interesting, usable hybrids. Really, each sculptor needs a somewhat different clay, because no two of us have quite the same manner of working. We need a medium tailored to our own needs and idiosyncrasies. You could combine a Kentucky ball clay with a fire clay from Mexico, Missouri, and add a bit of Florida kaolin, for example, in a quite personal percentage.

An acquaintance of mine, a potter, devoted his master's degree study to the preparation of a workable body based upon clay which he had dug from his backyard, outside of Potsdam, in upper New York State. He has subsequently done handsome pottery using this mixture.

There is, certainly, meaningfulness in using that which is nearest, that which is handiest, and making it do. Knowing you can return to the clay at your feet and use it to do respectable sculpture may allow you to combine the more exotic clays with a touch more *élan*. But this is conjecture.

SPECIAL QUALITY OF CLAYS

The primary and secondary clays are, first of all, plastic, which allows them to be formed—modeled. The plasticity must be encouraged, however, as it is not always present to sufficient degree in the clay's natural state. The clay must be sieved, ground, washed, and judiciously mixed with other materials.

Moreover, the desired plasticity must be balanced by a resistance to shrinkage. The most plastic clays are also the most liable to serious shrinkage. And this, of course, causes distortion during the firing operation. (Adding *grog*—a fired, granulated, non-plastic clay—helps to control shrinkage; however it also reduces plasticity.)

The plasticity of a clay mixture increases during its storage. As water is added to the clay, the clay separates into particles within the liquid. The longer the storage, the more time the water has to enter into the smallest of the clay's particles. I make it a point to let a batch of clay that I have mixed stand for at least a month before I will use it. I wrap it in polyethylene sheets after I have shaped it into rough 1' cubes. When I unwrap it—if it is right—it has a pungent, fine smell. This assures me that the bacteria within the cubes have been at work. The organic materials within the clay have been decomposing; the clay has become more homogeneous, less granular, and more able to be modeled.

Clay has another nice quality: it is cheap. Large bags of it, hundred-pound bags of it, can be had for the price of a dinner. Of course, there are the freight bills—another reason for digging it from the backyard, as the Potsdam potter does. Yet even with the freight charges, it is still one of the least expensive, permanent materials available to the sculptor. Processing costs, too, are relatively modest, especially if you use a gas-fired kiln.

Consider the sculptor in bronze. The foundry costs for casting, say a 24″ standing figure from wax, run conservatively to $200 or $300—even more if the model has been done in plaster or clay. The sculptor who uses wood is increasingly faced with the mounting cost, as well as the scarcity, of well seasoned timber.

The newer approaches, such as the use of metal pastes atop Styrofoam, plastic fabrications, and direct welding techniques can be impressive in a large way. These approaches are less expensive than castings, because they do away with the foundry; yet they are not likely to produce sculpture with the nuance of a traditional bronze, a terracotta, or a marble.

PERMANENCE OF CLAY

Clay is permanent. True, it breaks, but it is not friable; it breaks into generally large and clean pieces. And now, thanks to the epoxy glues, it can be put back together in a nearly imperceptible way.

Clay is as permanent as you could decently ask things to be. For is not the little Monkey in Chapter One still holding his fruit after some 5000 years?

Except for the fact that her head has come off, my Sicilian Aphrodite (Chapter One) is as she was when made two centuries or more before the coming of Christ. Made of an especially low-fire bisque clay, she still stands for me, as she did for her first owner, in her rather slouched, self-composed, languishing way.

SOME DISADVANTAGES OF CLAY

Although clay is inexpensive, permanent, and easy to model, it has shortcomings, too. Its permanence is, after all, relative. Although the della Robbia frieze on the Ospedale del Ceppo is still in good shape—after being exposed to nearly 500 Tuscany winters—it would be silly to claim that clay is at all as permanent as marble or bronze.

When certain of its masses are over-extended, it has a regrettable tendency to sag during construction. Should the clay become too wet, it will slither apart; a mite too dry, and it will crack. It requires you to be quick and sure, for

its normal drying-out time will not allow you to delay, and it will not brook too many changes.

Another discouraging aspect of clay is its urge to fracture during its firings. If the kiln is poorly stacked, if the piece has been poorly constructed, or if the sculpture's walls contain air pockets, or if the heat of the kiln is uneven—all these conditions can cause fracturing. Again, for the preceding reasons the piece could warp and come from the kiln with its mood and its shape quite distorted. As I have indicated it can warp because of too little grog, too much of one clay, too little of another, and so on.

In the remarkable collection of Mr. Hanns Weinberg, the owner of the Antique Porcelain Co. Ltd. in New York City, there is a Meissen porcelain of a girl delightfully recumbent upon a scarlet-gold couch. Her body, pleasantly and even tantalizingly twisted, is said to have been exaggerated by the action of the kiln. In this case, the "distortion" has added some value.

BALL CLAY

Clays vary in their character, and hence in their usefulnesses. Ball clay is found in good quantity in Kentucky (available from the Kentucky-Tennessee Clay Co., Inc., Mayfield, Kentucky 42066); it is very plastic, fusible, and fine. It was originally "balled"—dug up into balls weighing some thirty to forty pounds—in Devonshire and Dorsetshire, England.

Ball clay is notably fine-grained, and suffers high shrinkage as a result. As its final near whiteness suggests, it is low in iron. At 1100°-1150° C. the Kentucky variety fires to a light tan or gray to near vitrification. Ball clays are traditionally added to kaolin, or china clay, to increase the latter's workability.

John Astbury, the potter who quite likely did *Figure of a Horseman* (Chapter One), was, by the way, the first Staffordshireman to use ball clay. This use of English ball clays, which fire out very white, results in the luminescence of the piece.

KAOLIN

Sometimes called china clay, kaolin was introduced into Europe by the French priest d'Entrecolles, who spirited its recipe from the Chinese who had scrupulously guarded it until that (for them) unfortunate time.

Kaolin is decomposed feldspar together with quartz and mica impurities. It is fired to porcelain by being combined with the more readily fusible petuntse, which is also a product of feldspar less seriously decomposed.

Kaolin has poor plasticity. It is highly refractory, which means that it tends to resist fusing into a vitreous form, and prefers to remain porous. It exhibits little shrinkage.

Deposits of kaolin are found in Cornwall, England (together with its mate, petuntse, it forms a substance called "Cornish stone"), in France at Limoges, and in Ludwigsburg, Germany. In the United States, there are good beds of it in Georgia, the Carolinas, and Florida. An especially good kaolin is mined in Edgar, Florida, and is available from the Edgar Plastic Kaolin Company.

FIRE CLAY

This is an excellent clay for large sculpture because of its coarseness and open texture. I expect the large *Il Pastore* (Chapter Two) by Arturo Martini was built with great amounts of fire clay, together with grog. Fire clay, like kaolin, is highly refractory, but will vitrify at 1500° C. or over. It is low in iron content, and as a result fires to a tan or a brown. A satisfactory Missouri fire clay can be obtained from the A. P. Green Refractories Co. of Mexico, Missouri.

TERRACOTTA

Having about the same characteristics as fire clay, terracotta is, indeed, only a low-grade form of fire clay. Terracotta contains more iron, however, and so fires to a pleasant, deep red. Cedar Heights Red Art clay—from Oak Hill, Ohio—is a good terracotta. It can be ordered from George Fetzer, 1205 17th Avenue, Columbus, Ohio 43211.

SAGGER CLAY

While refractory, like fire and ball clays, unlike them it is nicely plastic or "fat" and holds the

shape into which it is formed. It is used as an additive to fire clay and to terracotta to increase their strength and workability. You can obtain sagger from the Kentucky-Tennessee Clay Company.

BENTONITE

This is an important clay because of its plasticity. Small amounts of bentonite improve the workability of a clay body enormously. Bentonite also seems to firm up the clay body when it has dried. It has the disadvantage of shrinking greatly, however, and so it should be used sparingly when preparing a modeling clay.

EARTHENWARE CLAY

Containing much iron and other impurities, this clay fires to pink, red, brown, or black. It is fired at 950° to 1100° C., and emerges hardened but porous. When the firing is carried to or beyond 1200° C. all earthenware clay vitrifies to stoneware; the color becomes grayish, gray-brown, brown, or a near black.

THE BODY

The clay *body* which the ceramic sculptor uses to build his pieces consists of his particular commingling of the above-mentioned clays together with certain additives—a blend of available clays. After finding a blend that quite suits him, the sculptor is apt to guard the secret of his mixture with as much zealousness as the French chef Escoffier guarded the ingredients—and their crucial proportions—which went into one of his dishes. (Although, bewitched by Melba, the Frenchman did surrender to her the secret of his peach *spécialité.*)

It is understandable. When a man finds a body that goes through fire for him and comes out of it intact, not much warped, and bearing a pleasant, desirable tone, then who in his proper mind would want to decently share it? And besides, it probably took a long time to come by.

SPECIAL BODIES

As I have said, the purpose of experimenting with various proportions and kinds of mix is to find a body which serves your needs. You must find the right commingling of clays to allow you to work in your own way and realize your own style with as little trouble from the medium as possible.

You need a body of the proper plasticity and color, a clay which does not shrink too much, yet allows for proper firing. The fired result should have a surface which will take engobes and glazes and/or the various paints.

In short, you need to work to obtain a body that suits your special requirements. You must continue to combine and recombine the qualities of the assorted clays with as much enthusiasm and inquisitiveness as the good breeder combines qualities in animal husbandry.

As a beginning, here are a few basic clay bodies. From these, I suggest you begin experimenting with modifications, additions, and subtractions that will give you a material more specifically your own.

Here is a recipe for a practical porcelain body:

kaolin	4 parts
ball clay	1 part
feldspar	3 parts
flint	1 part

Or perhaps more traditionally:

kaolin	40%
quartz	25%
feldspar	35%

These mixtures produce a soft body. To obtain a harder body, increase the feldspar to 50% and reduce the kaolin to 25%.

Here is a body with which I have had good results, both at bisque firing and at high firing (Cone 4) as well. Of the one part grog, I like to use some 35% fine red and 65% coarser white.

Kentucky Special ball clay (or Tennessee No. 5)	2 parts
Cedar Heights Red Art clay	1 part
Cedar Heights Gold Art fire clay (or J. H. France, or North American, or A. P. Green Missouri fire clay)	2 parts
grog	1 part

GROG

As I have said, grog is composed of semi-fine, broken bits of fired clay. Its purpose, as an additive to the body, is to control shrinkage and to provide surface texture. (Note again the "sandy" surface texture of *Il Pastore* in Chapter Two, accomplished by using a great deal of grog.) Grog also quickens the drying process, because it provides more "openness" to the clay. It also seems to prevent cracking during the firing, during drying, and also during the time of construction.

PREPARING CLAY

Clays can be prepared manually or mechanically. It is a dusty, sticky, messy sort of job, especially if you choose the first method.

To do it manually, you first pour the dry clays you have chosen for your body, together with the additives, into a pan. The ingredients should be weighed with a degree of care and a record kept of the amounts of each. The proportions should be well mixed together, and here is where the dustiness becomes worst. I wear a mask that keeps most of the dust out of my lungs. (The silica, for one thing, is bad for you.) I recommend a mask: one with appropriate, changeable filters.

I mix my batches with my hands and arms, using my fingers to sieve, break up, and distribute the clays and grogs so that they are fairly evenly diffused. I suppose this could be done with a paddle of some sort, but not as well. Then, too, I do like the feel of the clay.

After the dry clays and the grog are intermixed, the mixture is added to water, not the reverse, or in this manual method you will produce an unmanageable lumpiness.

Soak the mixture for a time; then stir it again by using your arms and hands or, if you prefer, the paddle. Bring it to the consistency of thin chocolate pudding. If you are mixing the more sensitive porcelain body, this "slip" should be poured through a 100-mesh screen; a bristle brush—a toilet brush, for example—can be used to work the mixture through it.

Allow the clay to settle. I permit it to stand overnight. Then siphon off the excess water which will be found on the top; a soft, kneadable mass of clay will be left. You can also pour the pudding-like mixture into concave, dish-like plaster *bats*. This hurries the removal of the excess water, since the plaster absorbs some water, and some of it rises to the top.

MECHANICAL MIXING

It is somewhat easier to mix your body with mechanical help. The dry clays can be quite perfectly intermingled, for example, by the use of a mix-muller. Simpson Mix-Muller Division of the National Engineering Company makes a laboratory-size or pilot-plant device with a 24" to a 3'3" pan. This device mixes by means of a revolving crosshead with twin rotating mullers, moving in plow action and discharging the clays through a bottom door. A more modest muller-mixer, by Amaco, can be had for about $400.

To mix the clays with water, some sculptors and potters—those who like to battle the system—use washing machines. The older, non-automatics (the ones embarrassingly mounted with wringers) work quite successfully and, since they have little prestige, are easy to come by. Large quantities of clay can be mixed in a vat with the use of a plunger. A motor-driven propeller mixer with a long shaft (one that reaches to the bottom of the vat) is effective. The "Typhoon," a one-quarter to three-quarter horsepower indirect drive (1725 rpm) agitator, is portable with an adjustable mounting clamp and can be purchased from the Patterson Foundry and Machine Company, East Liverpool, Ohio.

Perhaps the most satisfactory method of mixing clays, as well as the most dramatic—and certainly the quickest—is by the use of the pug mill. The pug mill, an auger machine, allows the dry clays to be dumped into its trough, and then the water is added. The augering shaft carries the wet clay, mixes it, and extrudes it in a splendid thick sausage with a workable body.

On the first passage through the machine, should the clay be too dry or too "liquid," it can be tossed back into the hopper and redone. Actually, I make it a practice of passing the clay through my pug mill three or more times. The sausages of clay, tossed back into later additions of dry clay and ladlings of water, become more properly plastic. Also, the three or more passes through the machine insure that the clays are

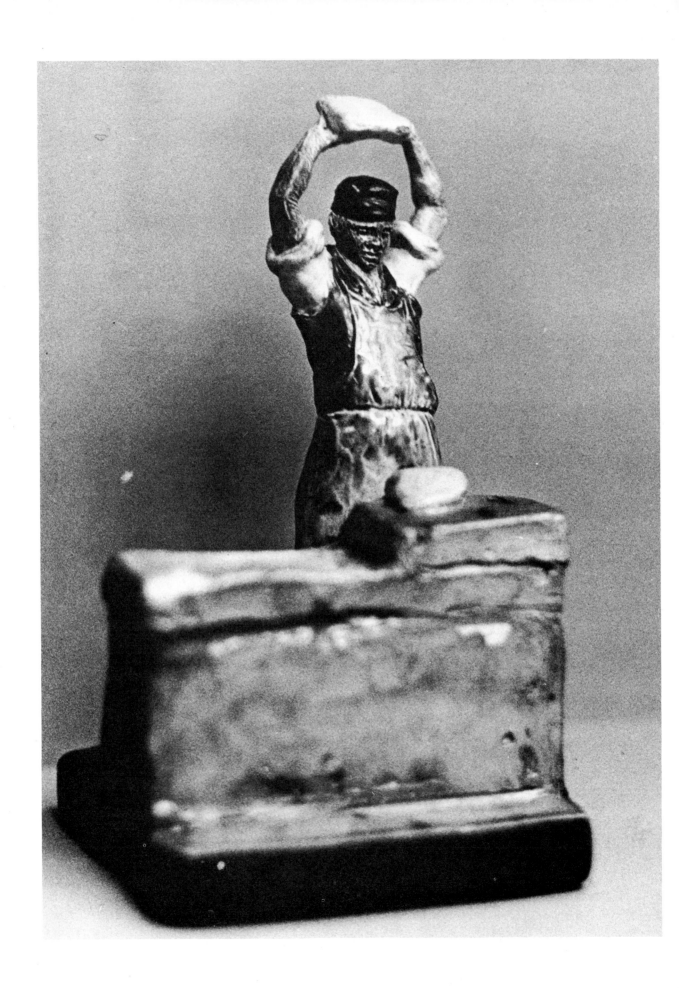

well moistened and well intermingled.

Pugging machines are expensive. J. C. Steele and Sons Company, in Statesville, North Carolina, produces a number of small, strong industrial models. I like the pug mills made by the Jamar Walker Corporation in Duluth, Minnesota. The Amaco Corporation supplies a table model which allows 100 pounds of clay to be processed an hour. It is driven by a one-third horsepower, 115 volt AC-DC gear motor, and costs around $500.

WEDGING

After preparing your clay manually, you'll come to the point where your clay is siphoned free of any excess water that may have collected upon it while in its pan or been absorbed by the plastic vats in which it has lain. If you have prepared your clay by machine, this is the point where it lies in sausage-shaped lengths, having come through the pug mill. In either case you now need to wedge it.

The figure in the sculpture *Bench Boy* is wedging clay. Amounts of clay, such as he holds, are plopped and kneaded upon a *wedging table* until the batch is properly conditioned for sculpting. This conditioning further increases the clay body's homogeneity, insuring that all air pockets have been removed and that the moisture remaining has been evenly distributed.

The wedging table has a thick plaster top and should have a steel cutting wire made taut by a turnbuckle. The clay is kneaded, then cut apart on the wire and thrown back together just as the *Boy* is doing. This is done for some time.

Some sculptors and potters, especially the Slavs and the Latins, knead the clay by dumping it out on the floor and working it about with their feet. Should you have a large amount of clay to wedge, I might suggest that you have a party and invite friends in to help. This could be diverting; it is also good for the metatarsals.

The clay is then formed into cubes about 1' in length, and wrapped in sheets of plastic. The clay cubes are then set aside, as I have suggested—for a week or two, at the least—to age them and thus improve their workability. A warm storage place is better, as warmth seems to encourage beneficial bacterial action.

Finally, it is easy to buy prepared sculpting clays from your local art supply store (or from George Fetzer or the Brodhead-Garrett Company, 4560 East 71st Street, Cleveland, Ohio 44105) and thereby save yourself most of the above pleasure or pain.

(Left) **Bench Boy.** *Robert Wallace Martin, 1881. Stoneware from the Southall potteries. Collection Victoria and Albert Museum, London.*

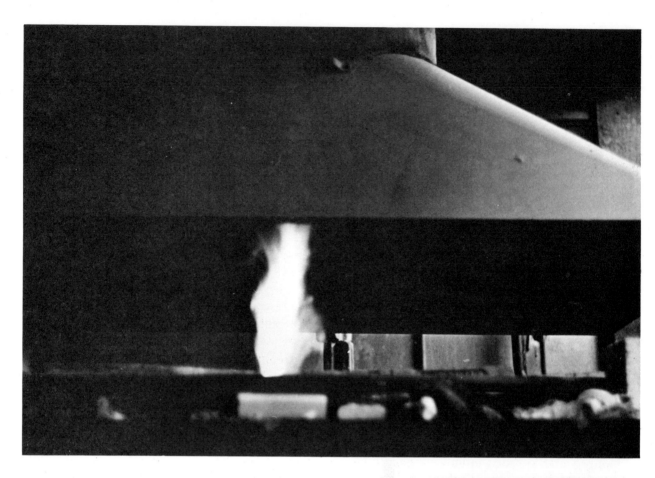

Figure 1. (Above) Here is a modern gas-fired kiln
underway.

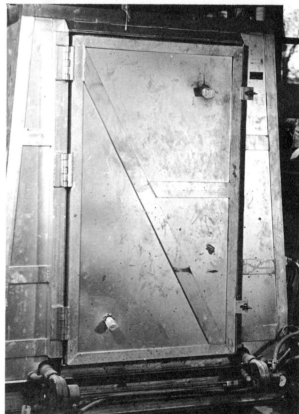

Figure 2. (Right) A model HF 30 gas-fired kiln made by
the A.D. Alpine Company, Inc. Culver City, California.
This kiln will accept sculpture up to 52" high.

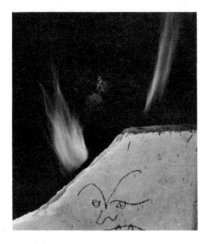

Kiln

Clay has been fired in the open air (while those concerned did ritual dances about it), fired within heaps of dung that were laced with dried grass, and fired in caves. The first kilns were simple up-draft affairs; the pottery and sculpture were placed on a grate floor over a pit containing the flame. Holes in the roof of the structure provided the draft.

The down-draft kiln, which allows for higher temperatures, probably originated in the Orient and was often constructed with multiple chambers to reutilize heat. Part of the success that the Orientals had with porcelain is due to the ingenious design of their kilns.

Today, the worker in ceramic clay has a great many types of kilns to choose from for his firing operation (see Figure 1). Many are very sophisticated and are manufactured to tight specifications. Others, though simply made, are still good. Some sculptors even prefer to build their own kilns, and this can be gratifying, economical, and sometimes useful in providing a flavor to the finished work which the commercial, more standardized kiln cannot duplicate.

In any event, it is important that you choose your kiln with care. It will be your comrade, helper, and taskmaster as well. You will need to cater to its idiosyncrasies and learn to make use of its particular virtues. You will be surrendering your sculpture to the kiln's treatment, and you will want to feel that you have placed your sculpture in good hands.

ELECTRIC KILN

Today's electric kiln is efficient and easy to operate; it is safe and easy to install. It has been accused of being more expensive to operate than the gas kiln, but this charge is certainly open to question. Many of the leading commercial and industrial ceramic plants use electrically operated kilns, and they surely have had their cost accountants study the matter carefully.

Another criticism of the electric kiln, one that is even more subjective, is the thought that the products that emerge from such an antiseptic, controlled atmosphere often seem flat and quite ordinary in color and texture.

Although there may well be a touch of truth to this, it would seem to be balanced by the despairs and disappointments that come from less efficient, less dependable kilns. The sculptor

would do well to befriend a kiln which may be a mite stodgy and a bit monotonously stable, but at the same time allows him to concentrate his excitement and energy on the shaping of the clay and the adventurous mixing of glaze.

The modern electric kiln is generally well-constructed of welded steel with adequate insulation. The elements are made of high-temperature Kanthal A-1 wire, fitted within high-fire refractory plates. The better kilns contain instrument panels which include pilot lights, vari-speed switches, and pyrometers for reading the temperature of the firing chamber.

The more modest kilns, which achieve a temperature of up to 2000° F., run on standard voltages of 110-115 volts AC-DC. The high-fire models run at 220-230 volts AC-DC, and these can achieve temperatures to 2900° F. Certain industrial furnaces, fired electrically, reach 5000° F.

There are various embellishments of kilns. The *pyrometer-automatic cutoff*, as well as showing the rise in temperature, turns the kiln off when the desired temperature has been reached. A kiln starter is also available.

One annoyance with the electric kiln—as far as the sculptor is concerned—is the usual dimensions of its firing chamber. Built to fire pottery, the kiln's interior dimensions are rather square and often considerably broader and deeper than they are high. The Amaco High Temperature Electric Kiln, for example, is a fine, medium-priced piece of equipment. However, it reaches 36″ high (with a width and depth of 20″) only in its AH-30 Model, which costs about $2000. The next model, A-21, at about $1500 is a 20″ cube. The A-10 drops to a height of 18″, with a depth of 21″ and a width of 15″.

Pereny Equipment Co. Inc., Dept. CD, 893 Chambers Road, Columbus, Ohio, produces a wide range of proven, rugged electric kilns (Pereco Electric Ceramic Kilns) for many purposes. The Denver Fire Clay Co., 3033 Blake Street, Denver, Colorado, produces two sound, practical D and E Series of electric kilns (which are front loading) and an A and C Series (which are top loading).

While the Amaco High Temperature Electric Kiln is a line designed primarily for the school, the "amateur" will find it solidly built; it can reach a maximum temperature of Cone 10, or 2350° F., which is enough for porcelain firing and more than enough for most stoneware.

GAS KILN

The gas kiln is more romantic. You are not reduced to just throwing switches, but need to *preside* over the firing. The usual gas kiln, requiring constant attention to its fluings, ventings, burners, and relays makes you feel very wanted.

It is certainly more flexible than the electric kiln. Glazes can be manipulated by way of reduction technique. This process involves a complicated feat where the amounts of oxygen entering the kiln are reduced in order to interfere with total combustion, and the fuel is changed to carbon. The subtleties of glaze manipulation can be accomplished only in a gas-fired kiln.

Whether the gas kiln is really less expensive to operate than the electric kiln, all things considered, is open to question. It really depends upon your location. I suppose it is not merely coincidental that a group of the best ceramists in America, along with one of the most noted schools of ceramics, are centered around Alfred, New York. The community of Alfred is blessed with one of the most plentiful (and the cheapest) supplies of natural gas in the country.

Daniel Rhodes, who has written several significant books on ceramics, works in Alfred. Lynn Phelan, long connected with the School for American Craftsmen, works in Almond, a short distance away. The Secrest brothers, who do much decorative, architectural ceramic sculpture, have set up their studio in the same region.

The disadvantages of the gas-burning kiln are obvious enough. It is dirtier than the electric. It is not always simple to install the fluings and chimneys in a manner which satisfies the local building ordinances. The gas kiln has a tendency to fire unevenly. The quality of the gas often varies, even with the time of the day. The sculptor needs to be able to handle the flues, burners, and dampers with great virtuosity. And finally, it is a more dangerous kiln.

I think the best gas-fired kilns for sculptural use are made by the A. D. Alpine Company, Inc., in California. The proportions are good. The Model HF 30 (see Figure 2) will take pieces of sculpture up to 52″.

The F and OF Series DFC-Dickenson Heavy-Duty Line Kilns (front loading) are also good and are available with capacities of up to 22 cubic feet. These are made by the Denver Fire Clay Company.

OIL KILN

Oil kilns are less common, and are, at the most, useful where gas is not available. Their disadvantages include the need for storage tanks and the problems of fouled pumps and lines. Since the blowers must be driven electrically, the sculptor doubles his dependency not only upon his source of kiln fuel but also upon electric power. But then, many gas kilns require electricity also.

FIRING

No precise directions can be given for firing kilns, because, as I have indicated, each has its own characteristics; the gas has more, the electric less. It is necessary to become acquainted with the individual kiln before you can know quite what to do.

However, generally speaking, the kiln containing sculpture can be advanced by 50°-100° F. an hour. Thicker pieces of sculpture, or sculpture with exceptionally uneven walls, need to be brought along a bit more slowly. This, incidentally, is a slower rate than the usual temperature increase for pottery—at least traditional pottery—which has much more uniformity to its walls.

Kilns contain *peepholes*—you can see them plugged with shaped bits of fire brick at the upper right and lower left of the kiln door (Figure 2) and during a firing (Figure 3). You use them to look into the kiln to check the condition of the *pyrometric cones*, which have been positioned within the kiln so that they are visible through these peepholes. The cones are placed in groups of three: the cone at the left is softer than the central cone; the central cone is softer than the one to its right. More precise than the pyrometer, the cones are used to determine the effect of temperature inside the kiln.

When the first of the three cones starts to bend with the heat, the firing should be slowed. When the first cone has collapsed, the second has gravely bent, and the third has begun to bend, the kiln should be closed off and, if you are using gas, damped down tight. Of course, you determine the turn-off point by your choice of the cones.

Pyrometer readings should be taken throughout the time of the firing. Before the cones become unstable, the pyrometer is your only way of determining kiln temperature. As you see in Figure 4 it can be a device which fits in through the kiln's peepholes. In a different form, it can be affixed to the kiln or can be part of its instrument panel. A pyrometer is a thermoelectric coupling of two wires, one of platinum, the other an alloy of rhodium-platinum. These are covered by a protective shield. An electric current created by the heat of the kiln is set up and this activates a magnet which operates a Fahrenheit (or Centigrade) scale at the opposite end of the wires.

REACHING TEMPERATURE

After the kiln has reached temperature, it should, as I have said, be closed tight. When the temperature has lowered to about 400° C. (based upon the pyrometer reading), its door and its ventings can be opened a bit. The kiln may be "cracked." The sculpture may be removed at 200° C. with the aid of asbestos mittens.

OXIDATION

During the firing of gas kilns, you should be careful about maintaining oxidation. As I have intimated, the gas kiln is more flexible than the electric, because gas provides the opportunity to reduce the air and cause the appearance of hot carbon gas. This gaseous carbon, anxious to combine with such oxygen as remains within certain glazes, produces desirable effects. Yet if it is not planned for and happens in the wrong kiln a reduction can cause unhappy results.

The admission of too much air, by the way, will prevent the kiln from increasing its temperature. The flow of air must be controlled.

PYROMETRIC CONES

The pyrometric cone is, I believe, more accurate than the pyrometer in measuring the effect of kiln temperature. However, due to their nature,

Figure 3. (Right) *The kiln's flame comes through a venting.*

Figure 4 (Below) *This portable pyrometer fits in through the kiln s peephole.*

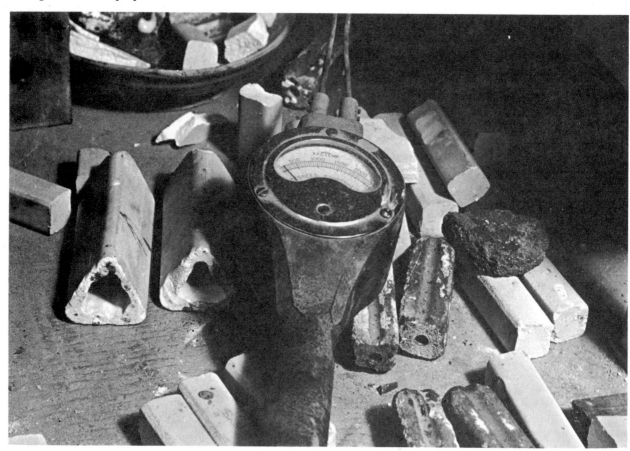

cones are used only at the final stage of firing.

A cone is a tilted, miniature "trylon" (Figure 5) carefully compounded to deform at different points on the temperature scale. (There was a big "trylon," if any of you recall, together with its "perisphere," at the 1939-40 New York World's Fair.) There are two brands of cones: the Seger (named after their originator) and the Orton: they differ slightly. Both are produced under careful controls. The Orton cone (obtainable from the Edward Orton Jr. Ceramic Foundation, 1445 Summit Street, Columbus, Ohio) is available in both large and small sizes. The large Orton cone (about 2½" high) is gradated from a Cone No. 022, which bends at 1085° F.

The small cones are used in automatic kiln shut-off equipment and are of little use to the non-industrial potter or sculptor.

A short table for the large Orton cones, in the more usual firing range for ceramic sculpture, is given below:

Cone Number	Degrees Fahrenheit
018	1328
016	1463
015	1481
014	1526
013	1580
012	1607
011	1643
010	1664
09	1706
08	1742
07	1814
06	1859
05	1904
04	1940
03	2039
02	2057
01	2093
1	2120
2	2129
3	2138
4	2174
5	2201
6	2246

The cones are used by imbedding three of them into a bit of sagger clay; the clay is perforated with a pencil tip to aerate it so that it doesn't explode in the kiln. Then the plaque containing

Figure 5. Pyrometric cones packed with vermiculite are pictured here.

Figure 6. Kiln shelves must be refractory; they must also be coated with kiln wash to prevent runs of glaze from bonding the sculpture to their surface.

Figure 7. *Posts, piers, rollers, and spurs as well as stilts pictured here are basically designed to support pottery but can be used for ceramic sculpture.*

the cones is placed behind the kiln peepholes. The inclination of the manufactured cones—8 degrees from the vertical—should be maintained when implanting them into the sagger or "cone pad." (As an alternative, it is possible to buy prepared plaques from the Edward Orton Jr. Foundation.)

KILN FURNITURE

There is a variety of kiln furniture available, largely designed for the use of the potter, but it can be useful, and often necessary, for the sculptor as well. There are kiln shelves (Figure 6), plates, posts, piers, stilts (Figure 7), spurs, saddles, crowns, rollers, etc.

The shelves need to be refractory to withstand high temperatures without surrendering to them. Tasil, a special, enormously refractory material, is used in the manufacture of the best shelving and is made from Indian Kyanite, chosen because of its low alkali and iron content.

Kiln wash is composed of one part China clay, one part flint (or zircon, which is somewhat expensive), plus enough water to make a paste. As you see in Figure 6, the wash is painted upon the shelving. This is done to protect the shelf against runs of glaze which might otherwise bond the sculpture to the shelving.

The other furniture, made of fire clay, has particular uses in pottery: the pieces hold differently shaped plates, bowls, cups, etc. in logical ways. When the sculptor is stacking his kiln he has the chance, and indeed the necessity, of using this furniture more illogically to support his unusual shapes. A complete line of kiln furniture is carried by George Fetzer, 1205 17th Avenue, Columbus, Ohio 43211.

KILN LOG

Finally, it is important to keep a careful log of each of your firings. Failures can be analyzed only by referring to the log of the firing. Moreover, successes can be duplicated only if you are able to follow previous logs—or if you are able to modify recorded procedures.

See Chapter Nine for an example of such a firing for a gas kiln.

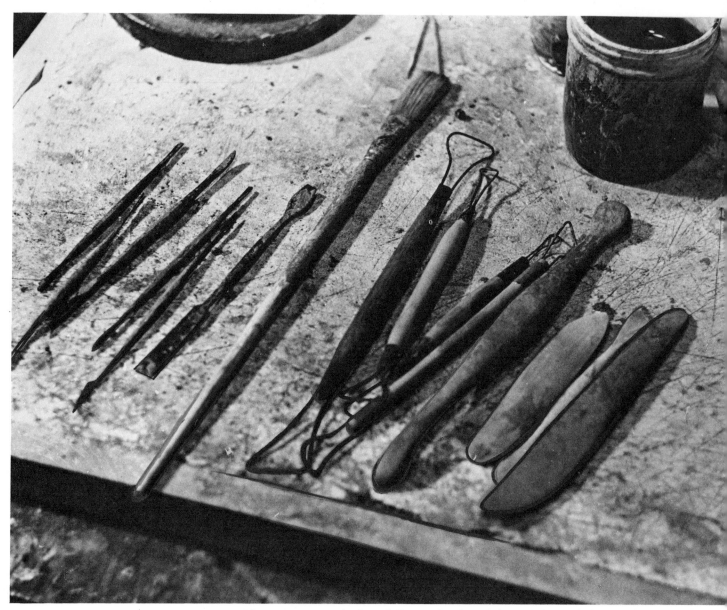

Figure 8. *A spread of modeling tools (from left to right) includes: steel tools with a variety of ends, a flat camel hair brush, double wire-end tools, and wooden modeling tools.*

CHAPTER FIVE

Workshop, Tools, and Equipment

The workshop of the ceramic sculptor should be separate from the rooms that he uses for other activities like sleeping, eating, and relaxing. It should certainly be separate from the kitchen. Many of the materials the ceramic sculptor uses—the clays and, most certainly, the glazes—are toxic. Then, too, there are great quantities of dust, which are not desirable in the home. And although you may like relaxing in your shop, and may not mind the dust, etc., it is perhaps well to find a place where you cannot see your sculpture in progress. If you look too steadily at what you are doing, you lose your objectivity and end up brooding about it.

I suspect that I have destroyed a piece or two which were not all that bad, only because I remained in their presence too continuously and had begun to magnify their faults at the expense of their virtues.

I know few sculptors who can work in a house together with their wives (or husbands) and children. There is something satisfying about the daily "going off to work" principle. I suppose it has something to do with our Calvinist/Protestant ethic. Wives and husbands, by and large, appreciate this regimen, too, even if it only means walking the few yards from the house to a shed.

To limit the dust you carry back and forth from your studio, you should change into comfortable, old clothes while sculpting. These will become quite caked and will seem, somehow, to mellow with the days, as does the clay. They could well become your favorite apparel.

WORKSHOP LIGHTING

I have some rather strong notions about lighting a workshop. I despise fluorescent light. It spreads a callous, oppressive flatness about the place, and it destroys volume, the essence of sculpture.

Moreover, it is a barbaric light. People lose their mystery, their privacy, beneath it. One of the peculiarities of the modern world is its predilection for an overkill of fluorescent illumination. Oh, I know it's cheap. But the unflattering look it gives to those trapped beneath its unrelenting, uniform glare is so obviously cruel that I should think the most close-fisted lighting engineer would be moved to pity.

Incandescent light is more to my liking. I prefer to house it in photographic, swivel-headed spots and floods: the clamp-on type, for overhead placement, and the floor tripod. These photographic fixtures are often good-looking; they work well, and are quite inexpensive as

compared to other fixtures.

I like to hang bulbs from their cords and perhaps cover them with paper bags. I also use shades fancied with satin and beads—so bad that they're good—that I come upon in second-hand stores. I leave bulbs that aren't frosted in their pretty nudity and when lit, they can show off their delicate, gleaming filaments.

The so-called "showcase bulbs" are special. Although not "practical" as studio light, they are certainly handsome. They consist of long, narrow clear glass tubes—like test tubes—from 3" to 12"; within each, there is an elongated, dragon-fly filament—an exotic, irrational touch.

I am not fond of natural light—even northern light. The changing quality of light from the east, south, and west is disturbing. A window facing west can be dreadfully hot in the summer; it dries out the clay. The cast of northern light is cold and unfriendly.

WALLS AND FLOORS

A smooth floor is a near requisite because it is easier to sweep up the dust and the debris, and to maintain a certain order. As a floor, cement is all right; so is wood. Tile, either asphalt or vinyl asbestos, is good if it isn't too obnoxious in color or pattern.

The walls should be pleasant to look at. If you are more than a dilettante about sculpture, you will spend long hours within them.

They should be a neutral tone, with few distractions. A bright wall—a currently popular "decorator" cleverness—might be all right elsewhere, but not in the studio. Should it be red, for instance, you could well find a corresponding (although unintentional) absence of reds in your paint and glaze when you take your sculpture out of the wall's influence.

Other art should not hang about. The presence of additional shapes makes it difficult to face the many discordant shapes in an emerging sculpture and bring them into harmony. Your workshop should help you to limit your attention to the emerging shapes of your sculpture.

WORKTABLE

The main studio worktable should be long, yet as far as I am concerned, no more than 36"

wide, that is, no deeper than you can reach across. It should be flat and strong; one section of it, set aside for drawing and sketching, can be arranged to tilt, if you wish. The flat part should hold a vise, which helps you to bend supports for your sculpture, to hold tools that need sharpening, to help build bases and pedestals, and to aid in shaping reinforcements for crates.

The space beneath the worktable can be used for the storage of pans, bats, and your kiln furniture. Beneath the drawing area, you can build shelving to hold sketchpads and papers.

SINK

You will need a large, deep, industrial-type sink. The faucets should swivel and have handles which are substantial and "unstreamlined"—the sort with knurled wheels—so they can be turned easily with slippery hands.

An ample sink trap—known as a "plaster trap," or *interceptor*—is essential. The amount of clay which finds its way through the drain is considerable, and it needs to be trapped before it enters and clogs the pipes which lead to your sewer. The traps made by the Hoffman Specialty Manufacturing Corporation, 1700 West 13th Street, Indianapolis, Indiana 46222, are good. They should be about a cubic foot-and-a-half capacity minimum and should be emptied regularly, of course.

WEDGING BOARD

It is possible to buy a commercial wedging board. Amaco makes a small one, about 22" wide and 14" deep. Its two surfaces are filled with absorbent plaster. A canvas cloth snap-fastens over one of the surfaces; here you can wedge clay which does not need any more water drawn from it. From a vertical backboard, a steel cutting wire runs diagonally down at a 45-degree angle.

I prefer a larger area and, therefore, have made my own table. It is about 4' square, built of 2" x 4" lumber. It has a top of poured plaster (quickdrying plaster of Paris) 3" in depth. Fastened vertically to the side of the table, at its center, is a 54" board. A turnbuckled steel piano wire runs from the top of the board to the two corners of the table on this same side.

In this way I have a cutting wire running at a 45-degree angle which is accessible from both sides of the table. The 16 square feet of table surface give me enough area to spread out large (200-pound) batches of clay and dry them out after they have been mixed with the propeller mixer or have come, perhaps somewhat too moist, from their pug mill.

TURNTABLE

It is necessary to revolve sculpture as you work upon it; all sides need to be developed more or less simultaneously.

I use a potter's *decorating or "banding" wheel* as my turntable. I prefer the cast-iron to the aluminum type, and the floor model to the table model. The floor model allows me to walk about my work without confronting a table. Both floor (with an adjustable shank) and table models are sold by Drakenfeld-Hercules, Inc., Washington, Pennsylvania 15301.

The heads of such wheels run from 7" to 14" in diameter. I prefer the smaller head, the 7" Certain plaster bats are built to fit over this to extend it. Then, too, pieces of 1" thick Novoply, chipboard, the heavier exterior plywoods, and ¼" to ½" Masonite, can be used.

Modeling stands designed more expressly for the sculptor are available from Sculpture House, 38 East 30th Street, New York, New York, as well as other places. Their Mark V modeling stand is a splendid workhorse; its reinforced steel frame can support loads of up to one-half ton. It has a crank and gear system and sells for about $300. A more modest steel stand, the Eldorado, at less than $100, supports loads of up to 350 pounds. A wooden affair, the Helsinki, can stand loads of 200 pounds, and costs about $30.

MODELING TOOLS

You don't need a great spread of modeling tools (see Figure 8). I use only a handful: a few double wire-end tools, for removing and modifying the clay, and a few wood tools for building and shaping. I also use several steel tools (Italian) with a variety of ends (saw-toothed, bladed, curled, etc.). These steel tools are used mostly by sculptors working in wax and wood for de-

tails which require finesse (usually toward the conclusion of the piece) and for achieving final textures.

Sculpture House sells a good spread of such tools. Some, called (unfortunately) "Claymates," are made of stainless steel with a variety of ends. There are also a whole line of boxwood tools in many different shapes and three different lengths—6", 8", and 12". Snakewood tools are made, as well as modeling tools of maple and brass, and maple and steel. Hand-forged steel tools, which look as if they had been made around Lucca, Italy, are also available.

Ersatz tools are often more interesting to use than conventional ones. Pieces of wood that you find or shape for yourself, as well as old dental tools, combs, sandpaper, spoons, toothpicks, pen-knives, pieces of glass, and parts of appliances are all possible tools.

Yet, for most things, the fingers are the best tool that you have.

AUXILIARY TOOLS AND EQUIPMENT

Any workshop needs hammers, chisels, squares, screwdrivers, saws, and pliers. The ceramic sculptor also needs asbestos mittens to remove his sculpture from the kiln and a decent dust mask.

Sheets of polyethylene are necessary for wrapping your cubes of clay and for covering sculpture in progress as well. Large sheets can be purchased from lumber yards at a reasonable price. Polyethylene is used as a storm window substitute and to protect construction workers from the wind and cold.

I have mentioned the desirability of adjustable photographic light stands. As you work on a piece of sculpture, lights constantly need to be shifted and adjusted to study and arrange the play of shadows and to illuminate the areas upon which you are working.

Incandescent, flexible-arm drafting lamps are also good. The Swedes make an especially fine one, well-weighted and free-floating (although expensive), which can be found in some medical supply stores.

Your workshop should also have a supply of cardboard tubes, drinking straws, newspapers, paper tape, etc., for armature building. Quantities of scrap foam rubber (available from most

Figure 9. A glaze shelf holds jars of raw materials, as well as the glaze mixtures themselv

fabricators of this material) should be around for propping work in progress, for packing sculpture which must be shipped, and for wrapping work which only needs to be locally moved.

Covered pails are needed to salvage clay parings and scrapings that fall onto the modeling stand. You can save yourself a good amount of the labor required for clay preparation by saving such scrap.

It is not, however, useful to save the clay which falls to the floor; this had better be discarded.

Sketchbooks, sketchpaper, and pencils need to be handy for sketching modifications and planning adjustments in the sculpture.

Since inspiration doesn't appear on schedule, paper and pencil are needed to jot down a new idea when it does decide to present itself to you. Somehow, truly inspired ideas come so seldom, no artist can be so prodigal as to allow them to pass by.

GLAZE MATERIALS

To glaze, you need the raw materials with which to concoct your patinas. You also need bins and bottles to hold the materials, as well as the mixtures. In addition, you need scales to measure the materials, sieves to strain them, mortar and pestle, and a ball mill with which to grind and to mix them.

Since many of the materials are toxic it is most important to construct or purchase a bin and shelving system for your workshop. This shelving system will keep glaze materials separate, and keep orderly the more dangerous materials in tightly-covered glass jars (see Figure 9).

GLAZE INGREDIENTS

The subject of glaze is a vast one; it deserves a separate book or books. Fortunately, the writings of Daniel Rhodes, who has published *Clay and Glazes for the Potter*, as well as *Stoneware and Porcelain*, are clear and thorough and the most explicit I have found about glaze. Yet should the sculptor in ceramic wish to embellish his work with glaze, he should stock the following raw materials as basics.

Kaolin. The main ingredient for porcelain bodies, it is also used to regulate the melting point of a glaze (it acts as a refractory) and is a constituent of *slips* (clay in liquid suspension) and *engobes* (coatings of slip).

Feldspar. An important fluxing agent, feldspar is used in the preparation of both earthenware and stoneware glazes. It produces a whitish, rather uninteresting glaze (at very high temperature) when used by itself.

Quartz. The commonest form of silica, it is a product of decayed igneous rock. Quartz is the fundamental material used in glazes. Don't breathe it; keep it carefully stored. Quartz (or flint, practically the same) is used to balance the alumina in a glaze. It provides a vehicle, together with its flux, which will mature slowly and adhere to the sculptural surface. It provides the glaze with its acidity.

Lead oxide. It is used as a flux to great advantage at the lower temperatures. Like most metallic oxides, lead oxide is poisonous. It is deep yellow in color. Avoid scattering the powder or taking it into your lungs.

White lead. Also poisonous, it is even more so than the lead oxide. By chewing at their brushes, and just being around it, easel painters used to die young because of it. House painters have mounted their scaffolds far fewer times. Yet it does produce a glossy, elegant glaze.

Alumina. This substance is used in combination with *frits* (prepared glazes, usually of the unstable and unsafe bases such as lead and potassium; a process which stabilizes and detoxifies these materials). It is also used to prevent glazes from running, to modify the brittleness of a glaze caused by too much silica content, and to limit the opacity.

Whiting (calcium). As an addition to glazes containing feldspar, whiting helps fit the glaze to the ceramic surface. It is a base for both stoneware and earthenware glazes.

Boric oxide. This is used as a flux for earthenware glazes, as well as a glaze when compounded with sodium oxide.

Potash (potassium oxide). Used as a flux, it is obtained from the ashes of vegetable matter, as are the lime, soda, and magnesium fluxes. Potash can provide bright, rich glazes when used as the melting agent.

Figure 10. (Above) When these porcelain jugs, or ball mills, are filled with the proper ingredients plus flint pebbles, they are placed on the ball mill stand.

Figure 11. (Right) A ball mill stand has two rotating shafts which turn the jugs containing the ingredients to be mixed.

Tin oxide. This is an opacifier when used in 5-15% proportion with an otherwise transparent glaze.

Zinc oxide. Also an opacifier, it is relatively ineffective. At a 5% addition it reduces the glossiness of a glaze and renders it more matt. Paradoxically, smaller additions than this will often cause increased gloss. It is also an effective flux.

Cobalt oxide. A most popular and ancient glaze material, it is obtained by the burning of cobalt. The blues in Delft china are due to cobalt (plus a dab of nickel), as are the blue-greens in the Ming. It is in majolica, and on the bluebirds which came out of Meissen.

Copper oxide. This substance provides a green and apparently was mixed with cobalt by the sculptors of the Ming epoch to give the miraculous sea tones with which they glazed their work. Copper can produce a variety of colors. In a reduction kiln, it can result in a rich, sanguinary red. With lead, it produces strong greens. In an alkaline glaze, the result is closer to turquoise. Heavily used, it becomes matt and blackly metallic.

Chromium oxide. When used in lead glazes, it gives a tart yellow-green, or, in differing proportions, gray-brown. When combined with tin, it gives rather odd, uncomfortable pinks.

Iron oxide. This substance provides, obviously enough, the red scale. Its presence causes the distinctive tone of terracotta clay, the fire clay. In glaze, it can move from the yellow-reds through the reds to the deeper red-browns. In reduction, blues and greens appear.

Manganese oxide. When added to lead glazes in small amounts, it allows for faint purples. Add a bit more, and brown occurs. Add 10% and you get black. Separate it from the lead, and a stronger purple is possible.

Nickel oxide. This substance helps create grays that grade all the way to the blacks.

Antimoniate of lead. It is poisonous, and looks it. It produces yellows in lead glazes and as antimony dioxide, it acts as an opacifier.

PREPARED (COMMERCIAL) GLAZES

There are several advantages to the prepared, commercial glazes. Perhaps most important, they are safer to use: you do not have the exposure to poisonous leads, the silicas, etc., that occurs when you do your own mixing. But the simplicity of using a prepared glaze is also a factor. Why do things the time-consuming way? Cut a corner or two when you can.

The commercial glaze is also, of course, carefully standardized by the quality-control experts who have recently burgeoned. These glazes are quite perfect.

The purist, however, will still say, "Yes, but" They do cost somewhat more, and—their gravest curse—they are ordinary. Anyone can have them.

In spite of these drawbacks, the Amaco people can supply you with a rainbow of glossy majolica glazes in either powder or liquid form as well alligator glazes, either matt or gloss. Opaque, opalescent, and iridescent glazes, all prepared to fuse at specific firing points, are also available from Broadhead-Garrett, or directly from Amaco.

GLAZE-MAKING EQUIPMENT

To avoid the commonplaceness—if that's what you think it is—of commercial glaze, you must grind raw materials together—mix your own. One way to combine the ingredients you select is to use the *ball mill* (Figure 10).

The ball mill *stand* (Figure 11) carries two roller shafts. These shafts, when revolving, cause porcelain jugs, filled to about a third of their capacities with flint pebbles, to roll (Figure 12). The pigments, frits, and other materials—carefully weighed and noted—fill another third of the jars, together with an equal amount of water and 3% binder (bentonite). The mill, electrically driven, revolves until the ingredients are mixed.

The A. D. Alpine Company, Inc., 1837 Teale Street, Culver City, California, makes good ball mill stands of heavy-duty welded angle iron, driven by a ½ or ¼ horsepower 110 volt single phase AC motor and drive. The Junior Ball Mill Stand can mix two 3 gallon jars at once.

CRUCIBLE

Should you wish to prepare your own *frit* glazes, rather than buy them, it is necessary to use a *crucible*. Gas-fired, or electric, the crucible is

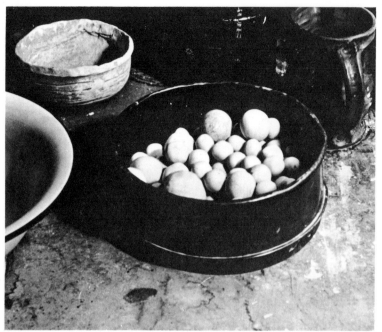

Figure 12. Flint pebbles are a necessary feature of a ball mill unit.

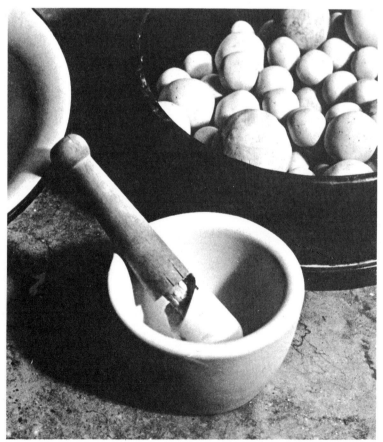

Figure 13. A mortar and pestle can often be used to mix the ingredients of a glaze.

capable of reaching temperatures which melt the unstable ingredients—borax, soda, the toxic leads, and silicas—into globules (by expelling the result into a pan of water). When ground into powder, these ingredients become non-soluble and less treacherous. However, it is really simpler to buy your frit ready-made.

SIEVES, MORTAR AND PESTLE, BALANCE SCALE

Production clays and other raw materials have such a fine grain that the *mortar and pestle* are often sufficient for mixing your glazes—especially in smaller quantities (Figure 13). The process is the same as that of the ball mill, except that the pestle takes the place of the pebbles, and the glaze ingredients are commingled with 3% bentonite (or gum tragacanth, etc.) and an equal amount of water.

When mixed, the glaze is strained through *sieves* into labeled glass jars. For straining glaze, you need sieves which range from 70 - to 100-mesh to the inch. The clays require coarser screens, from 30 to 80.

It is quite possible to make your own sieves by buying brass sieve cloth and stapling it to wood frames. You can, of course, buy circular, brass-framed sieves, too, and you should own a few because they are good-looking. Remember to save your glass peanut butter and coffee jars for the storage of your slips and glazes.

Finally, you need a *balance scale* (see Figure 14) of good quality. It should have attachment weights, so that you can carefully measure the proportions you use in your glaze. A good one can be obtained from Ohans, in Newark, N.J.

GLAZE PIGMENTS AND BRUSHES

The glazing section of the workshop can also include bottles of prepared paints to be used in glazing—and even crayons. Although they may have a bit of the "hobbyist" to them, crayons *do* work—and, in the right hands, very well.

The Amaco Company makes an underglaze crayon which can be used on bisque sculpture. It can be worked together into blends; it is really more a pastel to be followed with a transparent glaze. Opaque underglaze paint is available in jars in a good spread of color and can be applied to both greenware and bisque, followed with a

prescribed, transparent glaze.

Both underglaze and overglaze colors are available in the watercolor tray style and are used in the same manner as cake watercolor. The underglaze (Fine Art) colors are covered with lead or alkaline glazes. The same outfit makes a tube color with an oil base called Versa Color. It must be mixed with turpentine and used as an overglaze. It becomes semi-opaque at around 1300° F.

Lastly, you can "embellish"—and "corn up" as well—your sculpture with overglazes of gold and platinum. These overglazes fire from Cone 017 to 019.

The Amaco line of paint is produced by the American Art Clay Company of Indianapolis, Indiana, and distributed by Brodhead-Garrett, a huge craft supply house in Cleveland.

You will need brushes for applying the paint and the glaze. I like to use the flat camel-hair brush designed for the signwriter. The Robert Simmons Company, 555 6th Ave., New York, New York, still makes respectable brushes.

SIGNS

The workshop, as you can see, is not without its dangers. The clays are unhealthy to breathe and many of the glazes are toxic. The gas kiln can blow up; the electric kiln can short out and cause a fire. With its open hopper and revolving augering shaft, the pug mill is a very real hazard.

Signs placed on your door can remind you to turn off the gas or electricity. Other signs can admonish you to wear your mask and change its filters regularly, as well as to use the wooden tamper, not your hands, when running the pug mill.

To mellow the rather stuffy, alarmist nature of these signs, you might tack up a haiku or two. These may help you handle philosophically—despite the warnings—any accidents that may occur in your workshop.

FLOWERS, CAT, YELLOW CANARY, AND RADIO

I recommend a cat. A workshop needs a cat—preferably a neutered male. With its complacency and private contentment, a cat can inspire the sculptor to be a bit more patient. A workshop needs flowers to remind you of the importance of subtlety, of the fragility of things. In that way they can suggest that you should only be bothered with important things.

A yellow canary is a nice addition; somehow you must keep it away from the cat (that's your problem). The Fonderia Maf, in Milan, has canaries to sweeten the sounds of the crashing of bronze. In your workshop the bird's song can soften the ploppings of clay and your grunts while doing the wedging. More practically, if less benevolently, a canary can be used (I mean "used") to warn of high carbon monoxide/carbon dioxide levels.

A radio helps you keep in touch with reality. It should be turned to the "grittier" stations, rather than the classical FM, to encourage you to find your inspiration in the life of the times and not in esoterica at art shows and in the art magazines.

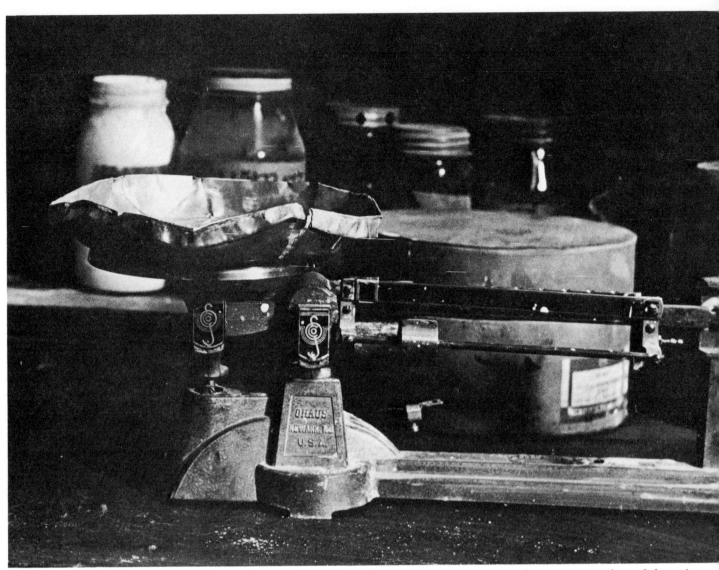

Figure 14. *A balance scale is needed to measure out the exact proportions of the various ingredients used in a glaze.*

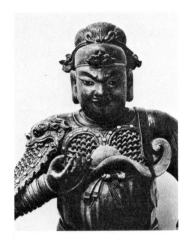

Glaze

Ceramic glaze is a subject too vast, too complex to be handled in a chapter. I mentioned this when I discussed glaze equipment and materials for the workroom. And I suggested that the book *Clay and Glazes for the Potter*, by Daniel Rhodes, be used as your text.

However, I do want to sketch an outline of sorts, for, as "clothes make the man," glazes can often "make the sculpture." More correctly, both clothes and glaze need to be applied over a body which is both elegant in proportion and noble in spirit, before either man or sculpture can claim beauty.

NATURE OF GLAZE

A glaze is basically a glass—a cooled solidification without crystallized structure. It is composed of silica (SiO_2, the acid), together with a flux (such as lead, soda, potash, titanium) to lower its melting point, and alumina (Al_2O_3), which increases the glaze's viscosity and causes it to adhere to the ceramic form.

Since the clay body of the sculpture is also largely silica and alumina (together with smaller amounts of other materials), when the glaze reaches a certain temperature, it incorporates itself, more or less, with the piece. The glaze and the sculpture marry.

GLAZE PROPORTION

In preparing a glaze, correct *glaze proportion* must be obeyed: the proportion of acid to alumina to the flux, or "base." The standard proportion is two to four parts of acid to one part flux, the alumina comprising 10% to 20% of the acid. For harder glazes, the amount of acid is increased to three to four parts; for softer glazes, the amount of acid can dip to one and a half parts. Should the flux, or base, be composed of more than one element, it should be measured so as not to exceed the one part which it is permitted.

To prepare a glaze recipe, it is necessary to figure the molecular weight of the glaze ingredients in order to ascertain the exact quantities of each part of the glaze. This is done by adding together the atomic weights (the total weight of the atoms of one molecule) of each of the elements comprising the glaze ingredient. For example, should you wish to calculate the proportions found in the black glaze given at the

end of this chapter, you need to know the atomic weight of the frit-lead bisilicate which forms a large part of the glaze. In formula it reads as $PbO\ 2SiO_2$. You would add the weight of PbO as Pb or lead at 207.3 and oxygen at 16, for a total of 223.3. This would be added to two times the weight of SiO_2 (flint), the S_1 (silicon) at 28, the O_2 at 16 times 2 (for two atoms), or $2(28 + 32)$, which equals 120. The sum total will then be 343.3.

After determining the molecular weight of each of the raw materials, the sculptor multiplies this weight by the allotted proportion of acid to alumina to base which he has assumed is appropriate. This gives him the distribution of each material in terms of molecular weight. From this total, the percentage of each of the materials can be determined.

Such information used in weighing the materials is also entered in the sculptor's records to guide him in preparing future glazes.

KILN FACTOR

It should be mentioned that when modifying the proportion of flux in a glaze you should consider the kiln firing temperature as a factor. A preparation that has proven to be too liquid at Cone 6, for example, might be just right at Cone 1. A glaze unpleasantly flat at Cone 1 could, on the other hand, become translucent at 9, and so on.

QUALITY OF GLAZE

The color of a glaze is modified by the addition of coloring oxides. As I have mentioned when listing certain basic raw materials, the metallic oxides such as cobalt, copper, chromium, manganese, and iron provide good blues, purples, greens, yellows, and reds, respectively, when used in a glaze. Other metallic oxides such as nickel, titanium, and uranium act as pigments for the creation of color in glaze. Nickel dioxide and hydroxide are also used, the former changing the usually green-black cast of the oxide to a dark gray, the latter to a strong, quite primary green. Cadmium sulphite, cerium oxide, potassium chromate, and gold and silver chloride are used as glaze pigments as well.

The brightness or dullness, the opacity or transparency, and the relative gloss or flatness of a glaze is, as I have said, varied by the recipe. The various fluxing agents play their roles, as well as the proportions of each of the agents used.

TYPES OF GLAZE

Glazes are typed, or classified, referring to their largest component of flux. An "alkaline" glaze, for example, is one in which the major part of the flux is lithium, potassium, and soda. A "boron" glaze produces a good turquoise when used with copper and an unusual, seemingly deep blue with cobalt. This glaze depends upon its boron, a metallic oxide, to flux the silica. While doing so the boron, also in its oxide form, is acting as a part of the glaze. Zinc oxide acts in this way as well, being able to flux silica while also playing its part in the glaze.

An alkaline glaze is able to mature at low-fire (beneath Cone 02) and is usually glossy and brilliant. *Crazing* is the tendency of the more brittle glazes to shrink more than the clay does, causing the glaze to splinter into segments. After the firing, crazing is expected, but this can be a virtue, because a good craze is not without beauty. Crazing can be controlled to a point, if you wish, by the addition of measured amounts of silica or flint.

The lead glaze is also basically glossy and clean. The flux is predominantly lead in its oxide, bisilicate, or sesquisilicate form. These clear and glossy characteristics can be modified by adding such ingredients as whiting, barium oxide, etc. Too much lead, especially if it is unfritted, can cause a yellowish cast. With copper, a lead glaze becomes green; with manganese, brown-purple.

Lead is perhaps the oldest fluxing agent. Its use by the earlier Chinese sculptors suggests that they learned about it from the potters of the Roman Empire, just as the English potters learned the use of lead glaze from their Roman invaders. Lead glaze, especially when compounded with lead oxide, fluxes readily at very low temperatures, which helps explain its early usage.

SURFACE MODIFICATION

The relative degree of translucency, opaqueness, gloss or matt, and the depth of a glaze can be modified drastically by changes in glaze recipe. Tin oxide, for example, in a 5% addition, with zirconium oxide in a 7% addition, can change a glaze's translucency to opacity. The addition of 5% rutile and 5% oxide of zinc can change a shiny glaze to a matt one. On the other hand, the use of alumina can prevent opacity and encourage luminosity.

It is interesting to have these options available, and worthwhile to devote some time to the development of a series of glaze recipes which can give you a palette of glazes. You can create glazes with varying surfaces, which are flattering to your type of sculpture, which work with a certain dependability—don't pock, crawl, blemish, or crack off—and are uniquely your own.

GLAZE TECHNIQUE

There are a number of ways of, and times for, applying glaze to sculpture. One such way is by using an *engobe*, or *slip*, and applying it to the clay when the clay is leather-hard but unfired.

An engobe is simply a liquid form of clay with the earthy color of clay itself. It provides a tone that is somewhat different, perhaps more uniform, than the sculptural surface itself. Such a slip, or engobe, with its lighter or darker tonality applied over textured sculptural surfaces can also add richness by increasing the sense of depth. The texture is thrown into a greater, if illusory, relief.

A near-white slip can be obtained by mixing kaolin with ball clay and fluxing this with feldspar and 10% flint. The materials are soaked (at least overnight), then put through a sieve (80 mesh) while at the consistency of yoghurt. Bentonite at 1% acts as a floatative to keep the ingredients in a relative suspension.

It is also necessary to *deflocculate* your slip. The acidity of the clay causes the slip to coagulate. An addition of very little sodium silicate or sodium carbonate (no more than 2%) discourages this tendency and gives the slip more fluidity. The deflocculant is added to the water and clay before it is strained, undergoing the same overnight wait.

To gain tonalities and hues, the colored oxides are added to slips. A black slip is obtained by mixing about 5% iron oxide and 5% manganese oxide with terracotta clay. After adding the bentonite (to keep the ingredients suspended), and the deflocculant (to prevent coagulation) to the slip and allowing it to soak overnight, it is submitted to water and sieve.

Finally, the composition of the engobe, or slip, needs to be reconciled to the clay of the sculpture, so that the slip does not shrink faster than the leather-hard clay. If it does you will find that your engobe, or slip, has peeled. Experimentation is needed.

SLIP APPLICATION

The potter dips, sprays, as well as paints, his slip or engobe on his pots. I would expect that the sculptor should stay with the brushes. If, however, you want to spray, you must strain your slip through a smaller sieve (100-mesh, at least) to prevent it from gumming your spray gun. You must also wear a respirator and use a spray booth to escape inhaling the noxious fumes.

SGRAFFITO

An application of slip upon unfired sculpture offers a tempting surface for doing *sgraffito*. The potter uses this name to describe an activity which we all seem to enjoy when we draw with our fingers on fogged, icy windows, or trace on the dust of cars. There is a pleasure involved here in penetrating a softer surface to get to a harder one beneath it. Nails, metal tools, the point of a pencil, screwdriver heads, combs, etc., can be used to trace linear and textural detail through the slip onto the leather-hard clay.

It is possible, too, to add color passages within and over (or under) the sgraffito, by using slips made from the various coloring oxides.

AFTER DRYING

In its unglazed state the slip often gives a dry, pleasant quality. The slip can also be covered with a transparent (or perhaps semi-opaque) overglaze. When both the slip work and the body have thoroughly dried, the sculpture can be put into the kiln.

SLIP UPON BISQUE

In addition to working upon leather-hard clay, the ceramic sculptor can use his slip, or engobe, upon a bisque surface, that is sculpture which has already experienced a low-fire kiln. This provides a flexible technique, even though it discourages sgraffito, because the bisque surface is too hard to penetrate with a flowing stroke and now needs to be chiseled. Bisque provides a handy surface to work on because the painting can be washed away—parts of it or all of it—and done over until it seems right. This allows you to be a good deal more spontaneous, because your over-exuberances or your *faux pas* can be sponged away. With the slate clean, you have a fresh start, and further exuberances can again be indulged until you find what you have been seeking.

Picasso worked with slip upon bisque at Vallauris. His potter threw pots; Picasso bent them. They were fired and later the painter worked upon them with prepared engobes. If he had approached this at all the way he does his paintings, I am sure that Picasso would have rinsed much that was unwanted, started over many times, and made many changes indeed.

The slip which is used upon bisque sculpture is necessarily different from that used upon the unfired surface. It is distinguished by a higher proportion of flux to clay, as well as by an increase in the bentonite. Also, you aren't allowed the choice you have with the unfired clay: with the bisque, an overglaze *must* be applied, in order to permanently tie the slip to the sculpture.

OVERGLAZE

A second technique is that of the *overglaze*. Here, colored glazes are applied over raw, white surfaces (as in majolica) or to an already fired, white or opaque surface.

In the former approach, the same pigments that are used for underglaze work are painted upon a usually white glaze surface which has not yet been fired. This raw, white surface usually contains some tin; the pigments are mixed with water and a small amount of glycerin. The technique—as is obvious in the Italian approach—allows the use of sgraffito.

Majolica fires at about Cone 05 to 04, at an Orton Fahrenheit temperature of 1922-1886 degrees. The underglaze pigments that are used must also, therefore, be prepared so that they are able to melt at this rather low temperature in order to fuse with the raw, white surface or glaze.

In the latter approach, colored pigments are painted upon a previously glazed sculptural surface, usually white. This white surface is usually high-fire porcelain. The results are bright, or can be, because the transparent pigments (those capable of transparency: copper, for example; never chromium) are illuminated by the high white gloss of the glaze which shines through them. The effect produced is much like the colored glazings over the neutral (white to deep umber) underpainting of Velásquez or Veronese, which provided them such depth and richness of color.

The decoration of the porcelain of Ludwigsburg, Fulda, and of Vienna and Sevres at the height of their glory pulsates with a sweet *joie de vivre*. These were painted with overglaze and then tastefully accented in gold.

Overglaze colors need to be mixed with a flux which causes them to melt at temperatures lower than those that would melt the surface glaze, for the obvious reason. It is quite possible to use commercial tube overglaze colors and work them upon a palette—intermixing them—much as the painter does. They are prepared so that you can work with either turpentine or water as your medium.

Should you wish to do it the hard way, you can mix your metallic oxides with lead or boron low-fire flux (one to one for matt, one part color to two to four parts flux for gloss) and mix this with turpentine on a glass or enamel palette.

When the painting of the colored pigments is finished, the sculpture is submitted to a second kiln—one which goes off at a lower temperature than did the one which provided the surface—and the overglaze color should fuse.

UNDERGLAZE

Finally, color can be applied to sculpture in *underglaze*, while the clay stands in either bisque or a raw, unfired condition. Here, when working

on the raw clay, the same approach can be used as when working with engobes, or slips, except that you will be using underglaze color instead of your slips.

Underglaze colors come commercially prepared. To prepare your own, you mix the coloring oxides with a proportion of the glaze that you will be using as the covering agent. A good mixture would be 30-40% of the glaze, 10% feldspar, and the rest pigment. Gum arabic or gum tragacanth is used as a binder.

GLAZE APPLICATION

The slips or glazes, in liquid form, are applied to raw clay in its leather-hard stage. When painted on bisque, the underglaze color needs to be somewhat less liquid, because less absorption takes place, although some bisque sculpture retains more porosity than others, depending upon the nature of its clays.

The underglaze color can be applied with a roller or a sponge. It can be trailed onto the clay with a syringe or commercial "slip trailer," sprayed, or spattered on. Sculpture can also be dipped into it, etc. I use a camel-hair brush to apply my underglaze color.

As I have mentioned, a small amount of bentonite added to the slip keeps its ingredients in suspension and makes it easier to work with. Sodium alginate helps in the same way. Gum arabic, added to the glaze colors, provides the necessary adhesion and prevents them from smudging before the sculpture enters its kiln and the applications are fused.

AN ARSENAL OF GLAZE

When all is said and done, I might mention that a great battery of glaze recipes, a cache of your own special secret formulas, will hardly insure your success as a ceramic sculptor. It might simply suggest that you have missed your calling and should have been a research chemist instead.

I have been told that Franz Wildenhain, one of the best working ceramists, carries in his wallet a few little frayed, folded pieces of paper, upon which he has jotted down his glazes. He takes these out, unfolds the tired things, and (although he by now certainly knows them by heart) mixes what he needs. Like the good grandmother who was such a fine cook, he never hesitates to add a little "pinch of this or that" just to see the reaction.

In all fairness, I suspect Mr. Wildenhain is somewhat more sophisticated than I suggest about glaze. His splendid ceramic mural in the Strasenburgh Laboratories in Rochester, New York, is a rich panoply of glaze. But like all talented people, he has the knack of doing what seems especially complex and difficult in the simplest and neatest of ways.

TWO GLAZE RECIPES

As a start, here are two decent glaze recipes, a black and a white one, to carry around in your wallet:

A black, semi-matt stoneware glaze:

65 parts P545 frit-lead bisilicate
25 parts china clay (kaolin)
6 parts whiting
9 parts Cornwall stone
10 parts zinc
(To be fired to Cone 5)

A white (eggshell), flat stoneware glaze:

65 parts Keystone feldspar
13 parts whiting
7 parts china clay (kaolin)
8 parts flint
10 parts barium carbonate
(To be fired to Cone 5, as well)

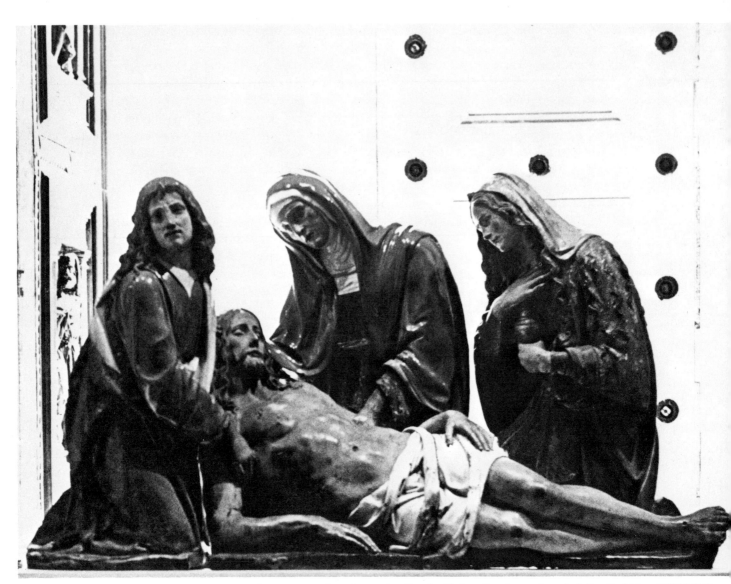

The Lamentation Over the Dead Christ. *In the style of della Robbia, 1500-1600. Collection Victoria and Albert Museum, London. The sculpture is partly painted and partly covered with polychrome glaze.*

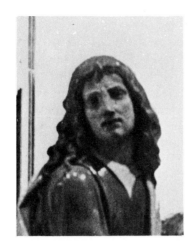

CHAPTER SEVEN

Selecting and Developing A Theme

We live at a time when the artist enacts the role of a last champion of individuality in an age of "mass." Thus, today each sculptor worth his salt is responsible for working somewhat differently from his fellows. His audience expects it. He must produce pieces which express personality; he needs to view the world with his own, private eyes.

Of course, this has not always been so. The nameless artisans who sculpted the saints which form the columns for the portals of the Cathedral of Notre Dame, did the Attic friezes, or those who fashioned the exquisite panoply of figures on the facade of the Bengalese Temple of Chaumukha, these men worked as teams—surely blissful teams. They did not have the responsibility of "originality," and, in fact, they would have failed in their task if they had felt and given vent to this need to create some highly inventive and personal work.

Today, however, without the circumstances which led to cathedrals, the sculptor is asked—by his clients, the collectors, his dealers, and judges—to present works which register character, that is, private works. His sculpture must be unique, so that it stands as a recognizable pro-

duction of an artist who deserves to be featured, exhibited, and sold.

When you are beginning, this need to build a personality into your work can be harmful. I have seen too many students, too aware of this need, turn away from any discipline—any planned procedure—feeling that this would pollute their creativity. Although long on uniqueness, they fall pitifully short on craftsmanship. The results of their work are often nothing but embarrassing; their sculpture seems to be merely private therapy; they are far too meager in reach.

Therefore, it is well to risk a loss of independence when you begin, and be willing to adhere to a procedure which others have used. (Picasso's earliest paintings, after all, looked like Toulouse-Lautrec's.) The procedure in this and the following chapter is offered as a systematic method of producing a piece of ceramic sculpture. It is not, of course, to be adhered to slavishly. It is simply offered as a reasonable method of obtaining a successful result. The sculptor can take increasing exception to this procedure—and indeed he should—as he matures and discovers his own, better ways.

CONCEPTION

The first step (perhaps obviously) is to find something to say. There are those, of course, who believe that you should address the clay without prior thought; they believe that the first handful of clay will offer sufficient suggestion, and that you can proceed from there in a "stream of consciousness" fashion. Most sculptors, however, prefer to have some prior notion of their theme. One major reason for this, especially for the worker in clay, is that his material offers more technical limitations than the material of the painter. The sculptor needs an idea that is clear enough to construct; ceramics built impetuously often collapse while in progress, and break during drying or firing.

You usually come upon the *theme* when you are observing and reflecting—often when you least expect it. The writer G. K. Chesterton has said, "no one, least of all myself, knows when I am truly working." And this is certainly true, too, of the sculptor. A shape seen in a rock, cloud, or tree; the sight of a face, the position of someone's body in a cafe—all seen when you are relaxing—can be of more use to you than time spent with clay. For it is in these relaxed moments that the sculptor conjures his theme.

Of course, you can also gain ideas while in your workshop. One piece of sculpture can well suggest the idea for another. Yet, it does seem true that the better ideas have a habit of appearing unexpectedly, at odd places and odd times. (The Muses, being women, prefer not to be too predictable, I suppose.)

It doesn't hurt to carry a sketchbook or camera. The fleeting face, so inspiring in the cafe, can fade before you reach the workshop. It is better to jot it down, make a sketch of the turn of the mouth, the flow of the hair, and the body's movement.

If a sketchbook makes you self-conscious or the camera makes you look too much like the tourist, at least carry a pen. Jot down your ideas upon coasters, napkins, shirt cuffs, hotel bills, and envelope backs. But get them down while they are vivid, hot.

SELECTING A THEME

The quick initial sketches, drawings, photos, notations (some sculptors prefer to *write* rather than draw what they see, then draw it only once, later) should be spread about and considered. You must select which ideas are worth development and which are only possibilities.

How to select the right theme? Obviously, you must decide which of the ideas looks interesting and remains so after a while. I find, personally, that just as it is important for the clay to age before it is used (and thus improve its workability), it is just as necessary to age your sketches for a time in order to be able to judge them objectively. (Vuillard claimed that he could not see his own paintings clearly until six months after they were completed.) I like to let my first sketches, less consuming than paintings, lie "fallow" for at least a week or two.

The fact that a sketch is "interesting," however, is not enough to entitle it to be used as a beginning for sculpture. Although it is important for you to be intrigued by your theme, you must also consider your idea in relation to the people who will see it, to the society within which it will live. (I am assuming that as a sculptor, you wish to set your works free and send them forth into the world.) You must ask yourself, "Does my idea, my theme, have relevance today? Does it offer the possibility of providing joy, inspiration, or relaxation? What effect will it have in the world? Will it shake people up; will it awaken them—stir them? Does it serve; does it please?"

REFINING A THEME

When you have gone over the first sketches, the photos, the notes, the doodles on coasters, etc., and retained the best, these should then be developed to scale. Soft white and black pencils, or pieces of charcoal and chalk should be used to expand these ideas upon good sheets of paper. Draw half size or full size—the actual size of the sculpture. Since sculpture is three dimensional, it is well to work in tone, ranging from black to white through gray upon gray paper (or dark brown, light brown and white upon beige); use tone rather than line. Moreover, it is well to draw two or more sides of the sculpture and place these next to one another to more clearly see how the piece will look in the round.

Next, pin the drawings to a wall. Leave them there. Consider them: how and where can

improvements be made? When you decide upon modifications—which are in most cases both necessary and encouraging for you—it is well to do them on tracing paper overlays, rather than erase and alter the original drawing. The reason, of course, is that if you erase the original to make the change, you can never quite know whether the change was for the good or not; you have lost your means of comparison.

Rather, place the tracing next to the original, and then make your decision—if possible, after waiting a time. At this point, after you have completed your scale sketches and made changes, it might be well to ask the opinions of others. Of course, these opinions should not necessarily be accepted, but the mere presence of others before your drawings has the peculiar effect of objectifying them, for some reason, so *you* see them more clearly.

MATCHING DESIGN TO TECHNICAL REQUIREMENTS

Technical consideration must always be given to your design. While refining the theme, while evolving it into a visual fact, the sculptor in clay must constantly ask: will it work technically, this pleasant and (by now) compelling idea?

If it cannot be erected, cannot survive the drying nor its ordeal in the kiln, the idea is a poor one and cannot fairly be entertained. It is most important while drawing to ask yourself: "To what extent can this projection that I am drawing—let us say an arm on a figure—be attenuated, extended? At what point will the bulk of its shoulder fail to support the arm's length? How thin, then, can I make the wrist, not only to satisfy my visual desires, but also to avoid cracking or breaking when dry?"

The nature of the clay—its desire to sag—makes it quite necessary to design pieces which are substantially heavier at the base than above. The sides should be wider at their base than they are further up, like the walls of adobe huts, or, to stretch a point, like the Eiffel Tower (although not really *that* extreme) to prevent the piece from collapsing. All except the smallest pieces must be hollow.

The Lamentation Over the Dead Christ, a Tuscan piece in the style of della Robbia, shows such a heavier base. When seen from the back,

the hollowness that I mentioned is also apparent. Also interesting here is the division of the piece into five sections (each figure is separate; the reclining figure of Christ is bisected within the loincloth) in order to make it easier to handle and to fire.

CONSIDERING CLAY'S CHARACTERISTICS

When you are drawing, the character of the clay should be considered as well. Its surface, as has been suggested, can be modified by various tools and techniques, by varying clays and grogs, and other additions. Should you wish to avoid textural monotony, introduce in your drawing differing treatments of surface, and balance these interestingly upon the sculpture to provide tactile and visual contrast.

As the draughtsman you should realize, too, that your medium is not wood, bronze, or marble, and your drawings should illustrate a design that flatters the special virtues of clay: its spontaneity, its ability to be manipulated easily, and the fact that it is a natural material without pretension.

While drawing, you should consider that you have the privilege of using glaze on the finished piece. In your drawing, you can determine which sections deserve glaze and which had better be left as they are. You should consider the choice of methods for applying glaze and the various effects which can result. It might be well, after the form has been more or less established, to place yet another tracing over the drawing and suggest different glaze solutions by the use of colored chalk shadings.

CONSIDERING KILN DIMENSIONS

Of course, as you consider your drawings with a technical eye, you should think of kiln dimensions, as well as the "disposition" of the kiln. All kilns, as I have mentioned, have their own quirks, and it might be prudent to design pieces which do not antagonize a kiln which has resolutely destroyed other works which have been constructed in similar ways.

More obviously, the piece should be a comfortable size. A piece too large for the kiln at hand, a piece which crowds it (less than 2″ from each of its walls, for example) can warp or discolor—or break.

(Right) **The Lamentation Over the Dead Christ.** *Viewed from the back, the hollow areas and divisions of the sculpture are revealed.*

(Below) **Le Parnasse.** *1779, Sèvres porcelain. Collection Musee de Sèvres, Sèvres, France. This piece is an example of a clay emphasizing not its own charming characteristics, but rather those of Greek and Roman marbles which were very in vogue at that time.*

Finally, it is useful when drawing to outline the hollow area within the planned sculpture with a red pencil. As I will show, all sculpture of a thickness greater than 2″ needs to be hollow. The hollow area within the piece needs to be continuous to provide for the free movement of air *through* the piece while it is fired. There must be no "pockets," no blockage. When the piece is under construction, the red lines showing the inner walls can point out the need for this flow.

PROVIDING A PROPER BASE

However, certain ingenious design elements can allow the sculptor to circumvent many technical problems and it is well to consider these while you are still at the drawing stage. One of the more annoying technical restrictions has always been the need to provide a broad, secure base with tapering top forms. The *Sicilian Aphrodite* (see Chapter One), for example, takes this in stride. The woman's chiton drapes amply about her legs and yet allows her modest breasts to be bared; she has a smallish head, coiffed hair, and quite narrow sholders.

Many sculptors in clay have been understandably irked by this limitation, especially those who have been interested in animals. The Ming Epoch artist who did the *Fu Dog and Rider* solved the support problem by allowing a saddle blanket to fall in a series of swirls, thereby providing a firmer foundation. Another Ming artist chose a dragon as a steed, instead of a dog, and by shaping the dragon in a serpentine fashion, solved the problem posed by the animal's four meager legs.

Shakespeare with his podium, his books, and his cape is also firmly, although maybe not too ingeniously, propped.

You should also decide during the drawing stage if your piece should be cut and fired in sections. It is possible with the development of epoxy glues to fire ceramic sculpture in this way and then bond it together after it has come from the kiln. While *The Lamentation*, as I have mentioned (although the effect is that of a single composition) is, in fact, skillfully divided, there is no need for it to be glued. Since clay is heavy and brittle, it would be well for you to design your larger pieces so that they, like *The Lamen-*

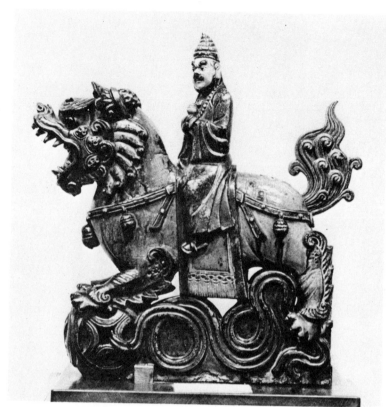

Fu Dog and Rider. Ming Dynasty. Collection Royal Ontario Museum, Toronto. The saddle blanket provides additional support for the sculpture.

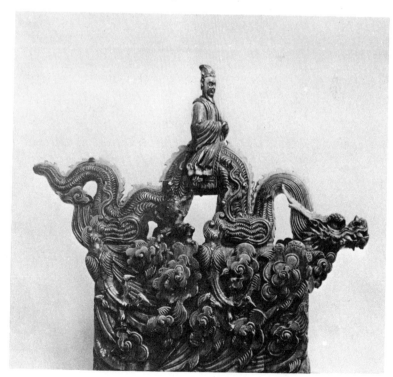

Dragon and Rider. Ming Dynasty. Collection Royal Ontario Museum, Toronto. The serpentine shape of the dragon provides support for the piece while creating an effective design.

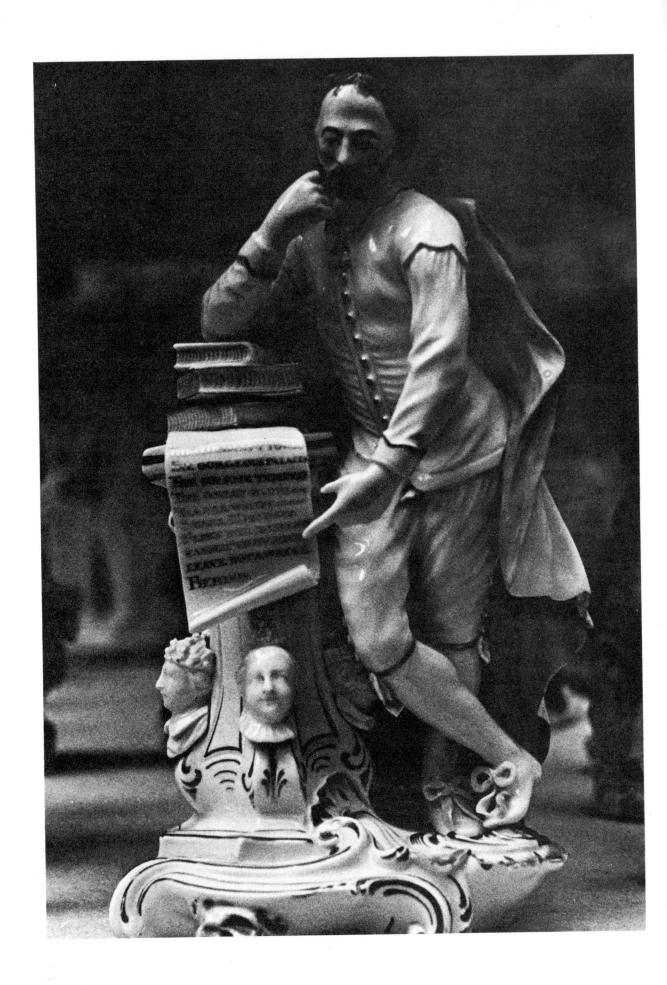

tation, cleverly key together. They can then be taken apart, moved without too much trouble, and reassembled without as much danger of breakage.

While it is being built, it is possible to support sculpture with cardboard. While in the kiln, it can be supported with separate pieces of clay; your drawings should, therefore, suggest where such buttressings can be placed. You can use a different color on those parts of the drawing which are only support, to distinguish them from the actual sculpture.

Lastly, as a draughtsman you should realize that color, both pigment and glaze, and techniques of carving and sgraffito can be used to create the illusion of lightness at the base of a piece of sculpture which would otherwise be too heavy. They can also be used to modify other areas by effecting a change in their form and their weight.

(Left) **Shakespeare.** *Staffordshire porcelain. Collection Victoria and Albert Museum. The bard's podium and cape help to support the figure.*

Figure 15. Here is cubed clay which has ripened within plastic.

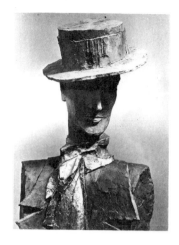

CHAPTER EIGHT

A General Procedure

When should you begin? You should take to the clay when your feelings tell you that you must, when the act of drawing begins losing its interest, and when you have been able to choose a drawing which you feel will make a good piece of sculpture.

Yet, as you take the clay into your hands, you must realize that you cannot simply copy the sketch. For the drawing should be but a preliminary, an estimate, a point of departure. The clay, in fact, will not let you imitate the results you have obtained upon paper; you will find that it has a life of its own.

When it is properly prepared, clay is fascinatingly (and sometimes disturbingly) self-willed. Because of its plasticity, and in accordance with the amount of water remaining within it, clay wants to slump and shift into its own configurations. True, you can guide the shape clay takes, but never completely. Rather than fight it, the wise sculptor allows the clay its inclinations and modifies his work accordingly. One reason is that the clay will crack less easily, it seems, if it is allowed to have its own way. Secondly, the shapes the clay moves into are often better than the shapes the sculptor had in mind.

You should, therefore, respect the clay and not impose a form upon it which it doesn't wish to take. At the same time, you should allow yourself to become enamored and not afraid of the clay. You need to enjoy its feel and its heft, yet you must realize that it will not want you to be its absolute master.

PREPARING THE CLAY FOR MODELING

The clay should age at least a week before it is used. Some chemical change, it seems, does take place, but it has yet to be precisely defined. Suffice it to say that after preparation it is well to keep the clay wrapped in plastic for a time; it works better when it is given the chance to ripen (Figure 15) and is no longer "green."

After it is removed from the plastic (I like to keep the clay in rough 12″ cubes), it should be rewedged. If it is too wet, kneading the clay upon the plaster table will take out some of the water. If it is too "soupy" to knead, you can allow the batch to stand in shallow piles, or smears, on the plaster until it approaches the consistency of peanut butter. This doesn't take a great deal of time.

The rewedging should continue until you are sure the clay is free of air pockets. Poke into it; knead it. Make sure it is homogeneous and that the grogs and clays you have used to constitute your media are thoroughly mixed.

Then reform the clay into smaller balls or cubes, so that is will be easier to handle. Wrap these in damp burlap, then plastic. If they are still a bit wet, wrap them only in plastic.

A word should be said about plaster. Plaster is both friend and foe of the ceramic sculptor. The flat table of plaster upon which he works is essential for shaping the clay and controlling its moisture. The slabs and coils that are used in building a piece of sculpture cannot be made very well without it. Yet, should bits of this plaster work into the clay, they can cause the sculptural piece to explode, either while being fired or later.

I have undergone the embarrassment of having sold a piece of sculpture to a collector who found (about a year after the purchase) that several shallow craters, each up to an inch wide, had appeared in the piece. Examining the pock marks, I found that at each of their vortices was a bit of white plaster, these no larger than a lady bug, perhaps a flea.

Hobart Cowles, my authority in this, claims that the plaster, remaining organic, resents being cooped up within the inorganic bisque or stoneware and, although it often takes it some while, attempts to break free.

You should be careful when you are working on the plaster table not to pick up bits of plaster with your clay. Your fingernails can do it. Be especially careful when you use knives to cut your clay into slabs. Be sure the plaster top of your table doesn't have cracks.

Secondly, it is wise to use only new clay. Clay that has been reclaimed—gathered up from a previous labor—is perhaps suitable only for private, preliminary sketches or props.

TWO METHODS OF BUILDING

The sculptor in clay usually begins building with "slabs" or "coils," because sculpture, if it is to be over 2″ thick at any point, needs to be hollow. It must be hollow to provide air passage, which limits distortion and prevents the sculpture from exploding while in the kiln.

In the *coil method*, the clay is rolled to lengths on the plaster table with the flat of the hand to thicknesses ranging from pencil to sausage. The coils are then placed atop one another, somewhat as a log cabin is raised. (The coils, being limp, need not be built up rectangularly, of course, but can be draped into any number of shapes.) The crevices between the coils (the soft logs) are then forced together with oblique strokes of a modeling tool and then smoothed.

In the *slab method*, the clay is pressed onto a burlap-covered board which is edged with railings made from 3/4″ wood stripping. Then a rolling pin is run along the strips. The clay within the rails (under the track) is thereby flattened into a slab of uniform thickness.

The purpose of the burlap is to hold the clay in place, to make the slabs a bit more flexible, and also to give surface texture.

Figure 16 shows a number of such slabs (prepared by Hobart Cowles) hung on burlap and ready for building.

Another method (the one I prefer) is to simply work the clay out by hand on the plaster table, somewhat as you might make a pizza crust. I press it out, work it flat with a spatula or a broad, wooden modeling tool, then turn it over and take care of its opposite side. Then I cut it (Figure 17) into panels, squares, and strips.

The thickness of these slabs, less regular than they would be with the railing and roller method, should not exceed 1½″, nor be much thinner than ½″. They can, and perhaps should, be thicker at the base of a growing sculpture than at its top. They should be thicker when used at the beginning of a projection than at its conclusion.

When the slabs are joined, their butting edges should be crosshatched with ½″ incisions made with a sharp tool. These edges are then painted with slip (clay body diluted with water) and the two slabs forced together. The outer and (if possible) the inner surfaces along the line of the joining should then be crosshatched or slitted obliquely over the seam to thoroughly wed the two slabs. Additional clay should be applied and these later incisions pressed and smoothed away.

If the slab cracks, or one of the seams comes apart after the area has dried to "leather-hardness," patching must be done by mixing some of

Figure 16. Slabs of moist clay, hung on burlap, are ready for modeling.

Figure 17. Clay worked out upon a plaster table is then trimmed.

the *dry* clay with vinegar (distilled white) and forcing this mixture into the vinegar-dampened split. The vinegar prevents the patch from shrinking, something watery slip cannot do. The split would continue to reopen, because its water would be absorbed into the drier clay at each side.

To build with slabs, you can begin by forming a boxlike construction, joining the four flat slabs at their corners. Or you can bend a longer slab into a cylinder and seam it at the meeting of its two ends.

This base, or beginning, of a piece of sculpture should be built upon a plaster slab, or bat, of sufficient thickness and size. A heavy piece of marine or exterior plywood can also be used. Since wet clay is deceptively heavy, be certain that the foundation you use will not bend or break while the work is in process.

To enable you to see all sides of the sculpture, you should use your turntable. The turntable is, as I have suggested, fundamentally important. Sculpture must be developed from all of its sides simultaneously. To bring one side to completion before another is often a waste of time, because the side that is more complete will often have to be broken down again, in order to reconcile it with the other, more slowly developing sides of the sculpture.

While it is being worked on, sculpture should, in most cases, be almost constantly revolving.

TIMING

When you are doing ceramic sculpture, *timing* is very important. While it is unwrapped and exposed to the air, the clay is forever drying. You will find that as you build, the lower portions of the sculpture will become harder. The color of the clay will begin to change. This drying out can be delayed by keeping the plaster bat or plywood base dampened, and also by limiting the breezes that move about your room. It can, of course, also be arrested by keeping those parts of the piece which you are not working on wrapped in damp burlap or plastic. However, unless you can see what you have done as you revolve your turntable, you will find it difficult to know how to handle the parts that are now being formed. The only answer is to time your work so that you can keep the piece exposed

long enough to make decisions and maintain a unity of design, and then cover most of it when you feel you can work more locally for some time.

When you take breaks or have lunch, you should cover the piece thoroughly unless you decide some parts should be firmer. Then, gaps can be left in the plastic to allow for these spots to dry. At the end of a working day, the plastic should be carefully wrapped around the sculpture, pretty much sealing it, with a wet sponge or cup of water placed underneath.

ARMATURE

To strengthen the sculpture while it is being built, an *armature* can be used. Since the armature, trapped within the clay, will need to go into the kiln, it must be composed of a material that will easily burn away.

Metal, obviously, cannot be used because it melts only at high temperatures, and also because it would not yield to the shrinking of the clay. (Clay shrinks while drying; it loses approximately one-seventh of its size in the firing process.) Ceramic sculpture armatured with metal (or wood; also unyielding, unable to burn out quickly enough) would soon shatter.

The armature must, however, be substantial enough to support the form of the sculpture. It must also be cushionable to allow for such clay shrinkage that occurs while the piece is drying, before it goes into the kiln.

Therefore, paper is an obvious choice. Newspaper crushed into balls or rolled into tubes can be used. When rolled, it is surprisingly strong. Straw, loosely bound, can be used also. For small sculpture, drinking straws make a decent armature material.

Additional support can be obtained, as I have mentioned, by propping the sculpture from the outside. Corrugated cardboard is handy. Pillars and buttresses made from scrap clay help to hold a piece in position. Wooden dowels, cushioned with bits of foam rubber to allow for the shrinkage, can act as supports. Squares of foam rubber are also useful.

WORKING TOWARD SPECIFIC TEXTURE

When the rough erection of a piece of sculpture has been completed, the sculptor must begin to

consider the more subtle matter of finish and modification.

The surface treatment of the clay, its patina, is very important. As you build to the final surface, you must know what surface you wish. Formerly, the surface of ceramic sculpture was usually worked with finesse. It was properly "finished." Today, the sculptor frequently prefers a rough, more impetuous handling.

Testa di Donna, by the Italian contemporary, Leoncillo Leonardi, is an example of today's more impatient, spontaneous style. The gloppings of his soggy clay as it is laid onto the head, the marks of his fingers as he spiritedly works, are left intact. This evidence of the passion with which the piece was created is considered to be intrinsic to its success.

Likewise, in Leonardi's more abstract *San Sebastiano Bianco* you are excited by the frothings of the surface and the bravura application of glaze. (Note here, too, that the piece has been cut horizontally at its middle, because of its size.)

Such spontaneous treatment of ceramic clay is not exclusive to the moderns, however. Giovanni Bologna, a 16th century Florentine sculptor, in his terracotta sketches, such as *River God*, (a model for *Appenine*, a sculptural panorama for the gardens of a villa at Protolino) manages a wonderful immediacy. Yet he was never as free as this in his bronzes.

Actually, it would not be overly surprising if today certain aesthetes would prefer the *back* of *The Lamentation Over the Dead Christ*, with its vigorous finger markings and shapings and its broad brushwork, to its more carefully glazed and fashioned front!

In any event, you must decide. Do you prefer to work loosely or tightly or somewhere in between? It depends, certainly, upon temperament. Successful sculpture has been done at all points along the line, and so has a great deal of bad stuff.

Arturo Martini's *Frammento* certainly suggests that his relatively tight technique, his restraint (the piece is unglazed), can still produce a beautiful object with a contemporary feel.

You should remember, however, that the simple tools the sculptor uses enable him to work in any manner, depending on the way he handles them.

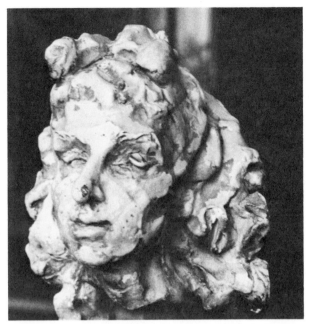

Testa di Donna. Leoncillo Leonardi, c. 1955. Collection Galleria Nazionale d'Arte Moderna, Rome. This piece, rendered with gusto was later dipped in a glossy glaze.

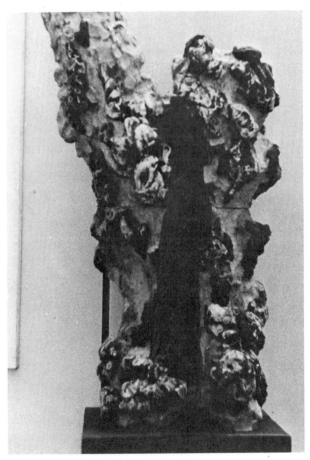

San Sebastiano Bianco. Leoncillo Leonardi, c. 1955. Collection Galleria Nazionale d'Arte Moderna, Rome. A bravura application of glaze marks this bold black and white piece.

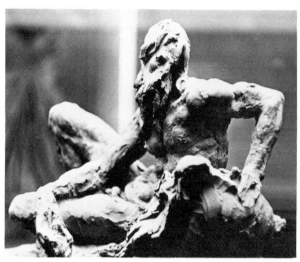

River God. *Giovanni Bologna, 1500-1600. Collection Victoria and Albert Museum, London. During this period, impetuous treatment was limited to the maquettes and did not appear in the final bronzes.*

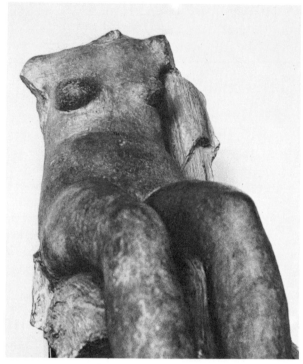

Frammento. *Arturo Martini, c. 1930. Collection Galleria Nazionale d'Arte Moderna, Rome. The handling of surface is understated in this contemporary terracotta.*

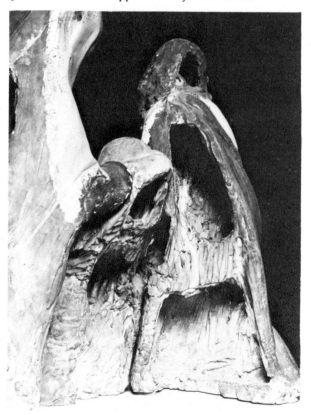

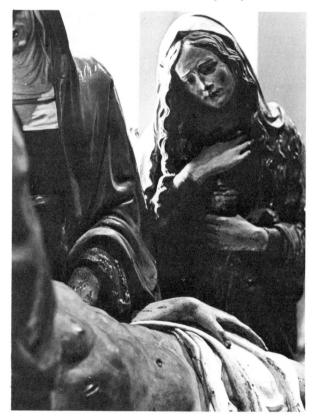

The Lamentation Over the Dead Christ. *In the style of della Robbia, 1500-1600. Collection Victoria and Albert Museum, London. In keeping with today's tastes, the rough shaping of the back of this piece (left) would probably be favored over its carefully glazed and finished front (right).*

DEVELOPING YOUR SCULPTURE

As you work your sculpture, pinch clay from one of the smaller balls or cubes you have prepared and add it to the piece with your fingers. (This is the classical method.) If you prefer, you can use a flat tool. When removing clay you can, of course, scoop it away with your nails, but a wire-ended, looped tool is more useful.

It is most important to keep the sculpture revolving, so that you are always aware of its totality. It is only then that you will know what to do in each section. Also, it is a good idea to step back frequently and consider what you have been doing from some distance. A reducing lens is helpful, especially if your working space is crowded or cramped.

LIGHTING YOUR WORK

You should work under the proper overhead lighting. Sculpture, because it derives much of its beauty from the interplay of light and shadow upon its surfaces, needs to be carefully lit. It is wise to develop your piece under lighting which is similar to the light it will receive when on display, so that the results of the studio will equate to the piece's appearance later. Natural outdoor illumination, as well as the spotlighting in galleries, exhibitions, etc., usually is from above; therefore, emphasize your overhead sources. A side light, should it be dominant, flattens the contrasts of light and shadow; it usually weakens the effect.

Keep your lights on cords, on tracks, on scissors extensions, on clamp-ons, on rollers, etc., so that they can be moved. You will find that you can "paint" with your lighting and modify the sculpture's mood, its very quality. This is interesting, but also sobering, because you then realize how powerless you are to control the appearance of your sculpture when it is out of your hands.

As you work, try to balance the darks and lights in an interesting fashion. Consider the relationship of sharp shadows and hard edges to the softer shadows and more rolling forms. Permit the effects to move contrapuntally from rough to smooth, curved to straight. Play the subtleties of delicate texture against the strength of large flat areas or bulky projections.

The head of *La Dormente*, by Arturo Martini (the full sculpture can be seen in Chapter Two), shows a nice balance between smoothness and roughness, darkness and light. Notice the straight, bristly markings in the hair at the girl's forehead, the curvy sgraffito which suggests the hair at her armpit. The rough, flat pressing of the hair which falls across her right ear contrasts with the smooth, rounded crest of her cheek.

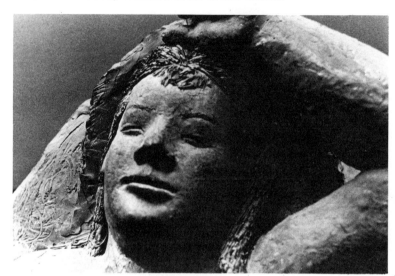

La Dormente. (Detail). Arturo Martini, 1929. Collection Galleria Nazionale d'Arte Moderna, Rome. From this detail the subtlety of surface treatment can be appreciated.

FINISHING

When the building and developing are completed, you should begin to let your sculpture dry. Free of its plastic, the clay will soon move toward leather-hardness. At this point, many interesting things can be done.

The underarm hair of *La Dormente* was *drawn* while the clay was still damp. Yet the wrinkles about the eyes and the furrows of the brow of the terracotta *Head of a Pope*, a 16th century Lombard work were *carved* into the clay when it had reached this point of leather-hardness.

The same is true with the carvings on the facades of the houses in the *Ming Compound*, the carving of the tiles of the rooftops, and the pattern of brick.

It is at this point, too, when the clay is leather-hard, that you can consider cutting the

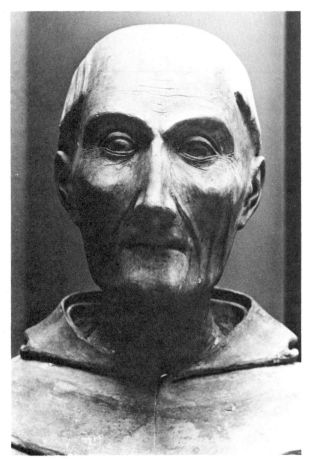

Head of a Pope. 1500-1600 Lombard. Collection Victoria and Albert Museum, London. The clay's surface was textured when it had reached leather-hardness.

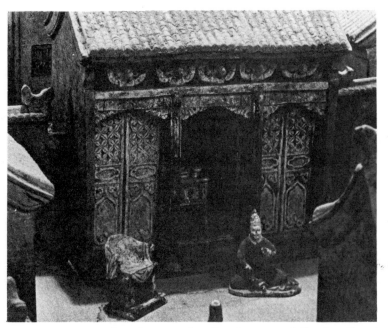

A Ming Compound. Ming Dynasty. Collection Royal Ontario Museum, Toronto. Here also the detail was added after the clay had hardened.

sculpture apart, if necessary, to fit it into your kiln. Also, the venting which allows the air in the kiln to circulate up and through the piece should be made at this time. Such ventings prevent warpage and lower the fracturing chances.

A top view of the *Sarcofago degli Sposi* shows such a vent hole in the top of the husband's head. The wife is vented through the back of her head, for some reason.

A Sicilian Aphrodite shows the vent in the back.

As your sculpture continues to dry, it can begin to be sanded and scraped. The great terracottas of the Renaissance, such as *Louis XV as Apollo*, were obviously sanded, filed, and scraped quite painstakingly to achieve their precise detail.

Finally, certain painting with engobe, or slip, should be done when the clay is in this leather-hard condition.

DRYING

Allow the piece to continue to dry in the studio until its color has turned from the darker tone to the lighter. You will see that the change moves from the top to the bottom as evaporation takes place.

The sculpture should then be moved to your *hot box*, if one is available. This can be a simple, airtight plywood closet, or cabinet, preferably lined with reflective aluminum foil insulation, housing a heat coil or heat lamp. Place your sculpture upon open supports, so that the hot air of the box can move up from beneath it.

The fact that the outer surface of the sculpture seems dry to the touch does not mean that the piece is dry *enough*, nor certainly dry enough *within*. It needs to be *completely* dry before it enters the kiln, or else it will break. A piece of average size should remain in the hot box one or two days. Should a hot box not be available, such a piece should stand (depending of course, upon the humidity of the room) for several weeks.

FIRING

After it is thoroughly dry, your sculpture goes to the kiln (Figure 18). Firing a kiln is somewhat expensive, however, especially the electric

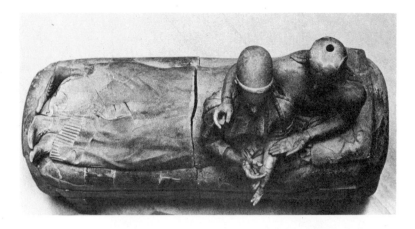

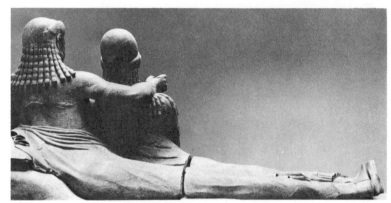

Sarcofago delgi Sposi. 650-600 B.C. Collection Museo di Villa Guilia, Rome. Viewed from above, this great Etruscan sculpture reveals its upper venting hole. (above). A second venting hole can be seen in the rear of the wife's head (right).

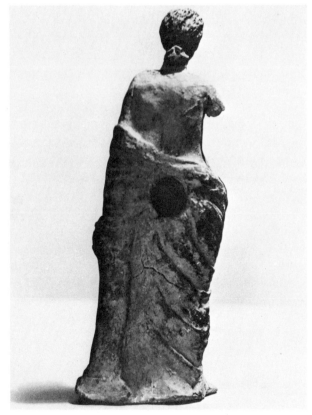

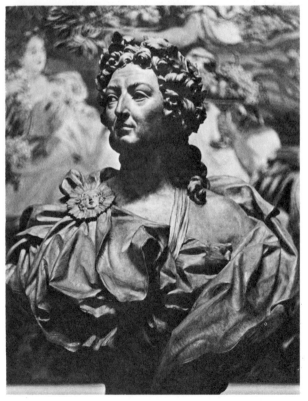

Sicilian Aphrodite. 300-200 B.C. Collection of the author. This piece is vented in back.

Louis XV as Apollo. Lambert-Sigisbert Adam, 1741. Collection Victoria and Albert Museum, London. This terracotta was meticulously and elegantly treated.

Figure 18. Pictured here is a gas kiln at high fire.

Figure 19. A triad of cones, seen here on top of the kiln door, are held in a plaque composed of kaolin and alumina.

variety. I have found it wise to hold my firings until I have enough sculpture to fill the kiln completely. There is a bit of "putting all of your eggs into one basket" about this, but I like to save money and rather like taking large chances. And actually, I suspect that a kiln works a bit better when it is fully loaded. Its currents move more evenly. Perhaps it feels it has a more important job to do when it holds a large block of sculptural effort and time and tries to live up to its greater responsibility.

The character and use of the kiln have been presented in Chapter Four; certain points, though, should be emphasized.

Be certain, when you load, that you use solid supports for your shelves and that you balance the shelves and the finished clays well. Use kiln wash on the shelves. Place the pencil-like ceramic rollers under those pieces of work which you suspect will shrink laterally to a greater degree—those pieces having the thicker, more uneven walls and unusual width.

If you are firing one of your sculptures in sections, make certain that the sections are fired within the same kiln (to equalize their shrinkage) and that they are at approximately the same distance from the kiln walls (to equalize their color). If your kiln is temperamental (like mine), the sections should be placed within those areas of the kiln that produce the most similar results.

After stacking, a triad of cones is placed behind the kiln door's peephole or peepholes. The larger kilns have two of them, one at the top and one at the bottom. Should you decide to fire to Cone 5, you will stand Cones 4, 5, and 6 in line, pressing them into a mixture of kaolin and alumina (as is the case with the setup standing atop the kiln door in Figure 19). The cones can also be held within a commercial plaque, but why bother?

Sculpture, unlike pottery (or at least traditional pottery!), has uneven walls. It must, therefore, be fired more slowly. As a rule of thumb, the temperature should rise about 50° per hour for the first three hours. It is well to hold it overnight at 300° or so to insure that your pieces are thoroughly dry. Then, the next morning, the temperature can be brought up more sharply, at say 100-150° per hour.

When your temperature begins to approach

the wanted level (you are, of course, carefully watching your kiln's temperature gauge, i.e. your pyrometer, and regularly entering its climb in your logbook), you taper off the fire. You begin the tapering off as the first of the cones (Cone 4, in our example) begins to bend. The kiln is shut down completely when the first cone (Cone 4) is flat, when the middle cone (Cone 5) is severely bent, and when the last cone (Cone 6) is beginning to bend at its tip.

The kiln can be cracked when the temperature is down to 350-500°, after you make peephole pyrometer checks. The pieces can be removed (with an asbestos glove) when the temperature has fallen to 150-200°. Then you can hold your celebration or wake.

STONEWARE OR BISQUE?

You will need to decide with each firing how high you wish to go, to what cone. Bisque, or "biscuit," generally results from firings of 800° to 1100° C., whereas stoneware results from firings from about 1100° C. to as high as Cone 9, or around 2500°.

However, different clays, different batches of the same clay, and the many mixtures of clays each require—depending upon their amount of refractory material, etc.—a somewhat different temperature to become healthy bisque or good stoneware. Some clays produce only one or the other, but not both.

The look and the feel of bisque are a great deal different from that of stoneware. Bisque sculpture—my *Sicilian Aphrodite* is bisque, as is most early pottery due to the firing factor—is soft, warm, and lightweight. It is also more fragile. Clays appropriate to bisque give tonalities ranging from creamy whites (excluding the porcelains, which are capable of a dazzling, pure whiteness) on through the range of ochres and umbers to the deeper Venetian and Indian reds.

Stoneware is more masculine in result. When tapped, it rings rather than plunks. Its tonalities are deeper and stronger. Its surface is often less matt. It is, of course, much harder. When it breaks, it tends to break cleanly (the bisque would more likely crumble) and can, therefore, be more easily repaired.

Some sculptors fire to stoneware in two stages, bringing their first stage to completion at

bisque. The kiln is broken open and the pieces removed; then they are often underpainted, or painted with engobes or slips. Glazes are often added. Then they are refired to the higher temperatures. The two-stage firing, even if surface treatment will not be done, has the advantage of being more precautionary, as less breakage seems to result.

POST-FIRING CHANGES

When the sculpture is finally done with its kiln, it can still undergo changes. Obviously, those pieces fired in sections will need to be bonded together (unless they are designed to be keyed). The epoxy resin adhesives are excellent and bond ceramic surfaces with little difficulty. However, the two components of the epoxy have to be thoroughly mixed and the ceramic surfaces dusted and clean.

After the bonding, should the crack between the sections offend you, you can mix a bit of the ground ceramic into more of the epoxy and smooth it into the opening. Or you can use metal or plastic filler and then match it—with acrylic paint—to the color of the sculptural surface.

Finally, if your result is unglazed or should certain sections be unglazed, you can paint the ceramic surface with artist's colors to change its effect.

The painting of ceramic sculpture is becoming increasingly popular. One good reason is that you can be quite certain of your result, which is far from true when you use glaze.

There are ceramic paints on the market designed to be used after the kiln, but the acrylics used by easel painters are better. They are durable, simple to use, can be thinned with water, and can be applied to the ceramic surface without priming or otherwise preparing it. Tubes of acrylic paint are available at all art supply stores and now even in discount department stores.

The disadvantage of acrylic paint is its unfortunate "plastic" look. This semi-shiny, rather cheapening quality can be somewhat modified, however, by mixing acrylic matt medium into the paint. Be sure the medium you use is made by the same manufacturer who produces the acrylic color.

A shiny surface can, of course, be successful.

Girl in a Geometrical Blouse. *Fred Meyer. Collection of the artist. The surface of this piece has been slightly modified with paint.*

Laurel and Hardy. *Fred Meyer. Courtesy Midtown Galleries, New York. This terracotta was intensely colored.*

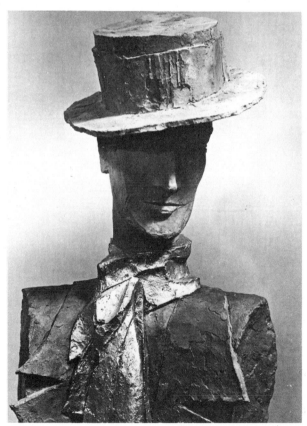

Maurice Chevalier. *Fred Meyer. Courtesy Midtown Galleries, New York. The scarf on the figure is covered with gold leaf.*

Much "pop" sculpture capitalizes upon glossiness, because it is, perhaps, symptomatic as well as descriptive of the culture. To heighten the gloss, you may add gloss medium to the acrylic pigment.

You can also use the acrylic gloss medium (or the matt) straight to provide protection (exterior or interior) for unpainted sculpture. It will dry clear, although it will appear to be milky upon application. There is, though, a certain deepening of clay color and a change, of course, in patina.

A piece can also be protected with wax. You can use a good carnauba wax, which is sold as a superior car and furniture polish. Or you can buy a box of exquisite wax "coins," each about 3" in diameter, made of pure beeswax and nicely embossed with a beehive, from Will and Baumer Candle Company, Inc., Syracuse, New York. You may possibly find such coins in an old drugstore, and melt them down with one third gum turpentine and one third Damar varnish. Brush the warm wax onto your ceramic. Polish the sculpture's waxed surface when cool, preferably after twenty-four hours.

Casein color can be used to paint on ceramic. It dries to a pleasant, velvety flatness, but is unfortunately not completely waterproof. Therefore, pieces painted with casein, unlike those done with acrylic, cannot be placed outdoors.

USE OF PAINT

I have a certain hesitation about covering the beauty of a good terracotta surface with paint, because the texture and color of the fired clay is so attractive in its own right. In my sculpture, *Girl in a Geometrical Blouse*, I have merely modified the surface slightly with paint and left the color emphasis to the blouse patterns alone.

In my *Laurel and Hardy*, I went further with paint and colored the shirts and hats more completely, while especially emphasizing Laurel's bow and Hardy's four-in-hand tie.

Maurice Chevalier deserved, I felt, a gold scarf, being a flamboyant, theatrical man. I applied gold leaf (Hastings 24 carat) to this section of the ceramic, after priming the surface with acrylic gesso tinted to the traditional Venetian red. I used a slow-drying gold size. When gilding ceramic, I use the same leaf signwriters use when working in the wind. It is a bit heavier and mounted on a firmer pink tissue than ordinary gold leaf.

Materials other than clay can be combined with ceramic sculpture after firing to create unusual effects. The sculpture should, of course, be designed with these additions in mind.

1. I begin building the sculpture by forming the first cylinder.

2. After adding a second cylinder to the first and slightly flattening them, I add a third cylinder which is in two sections.

Fred Meyer: A Specific Technique

The general procedure should admit to many variations, depending upon the temperament and proclivities of individual sculptors. Therefore, it is well to look in on the approaches used by a few such individuals, all Americans, and see how they work.

First, I offer my own approach to constructing a figure, *Girl in an Evening Dress.*

BUILDING WITH CYLINDERS

I incline toward realism, although I hope not at the sacrifice of transcendent beauty for the sake of the particular.

I use no sketches; I begin with only a vague notion: a girl I have seen, perhaps but fleetingly, out of a car window, at a dinner party, or entering a theater—one whose memory remains. Although I have only caught a glimpse of her, this particular girl will serve as my impetus; yet when sculpted, she will reflect my remembrance of many other girls as well.

After rewedging my clay, I work it out into a slab on my plaster table, trim it rectangularly, and form it into a cylinder. I seam it by scarring the edges of the clay (making small, sharp cuts with a knife) and forcing these together (*1*). I decide that I want to clothe this girl in an evening dress. I scar the top of my cylinder and add a second one to it, slightly flattening the two in the process. I smooth away the joining, or meeting, of the two and add a third cylinder. This third cylinder is in two parts (*2*). While building, I am careful to keep the inside of the piece completely hollow, so that I don't trap any air.

USING PAPER ARMATURES

As I reach the throat, I roll and insert a long tube of newspaper through the center of the neck down to the plywood base (*3*). This reinforces the neck, enabling it to sustain the weight of the head. It also assures me that the center of the sculpture will remain open.

I now bend a small slab of clay and form the beginning of the girl's head (*4*). I decide that the upper part of the body is too wide, and I cut some away (*5*).

After modifying the head a bit more, I roll another tube of newspaper and shape the armature for the girl's arm (*6*). The paper armature is

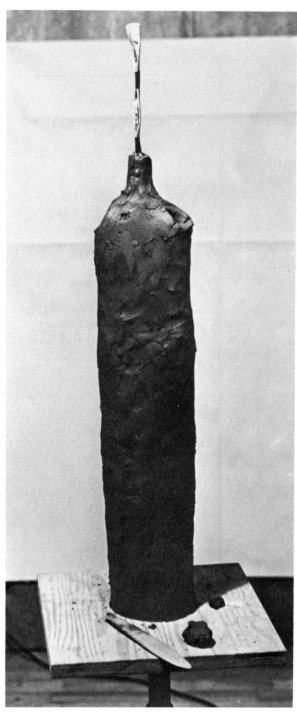

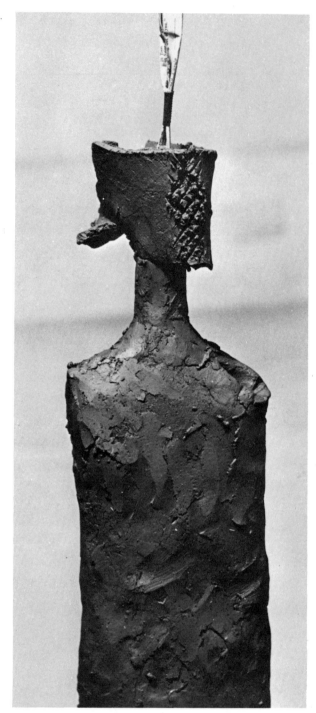

3. I insert a paper armature into the base of the figure.

4. I begin the girl's head.

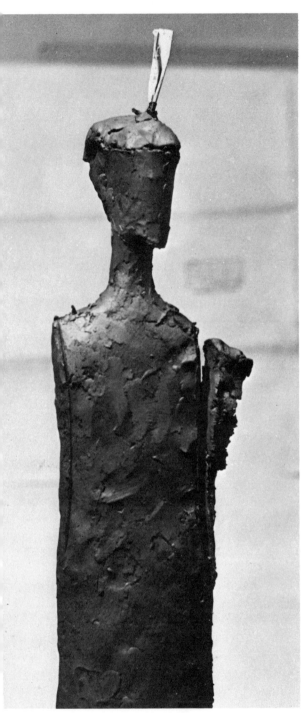

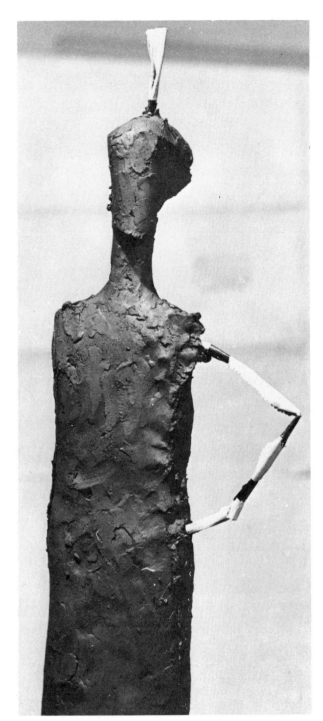

5. *Here I remove some clay from the figure.*

6. *I shape another paper armature to form the girl's arm.*

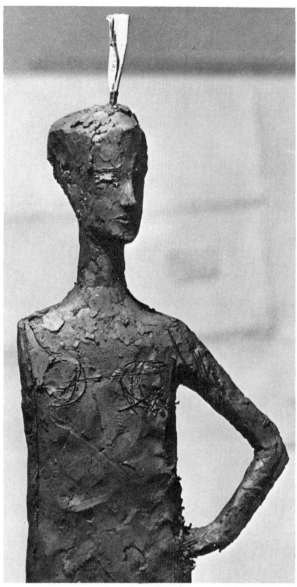

7. I sketch into the clay proportions for facial features and her breasts.

covered with clay, and the arm is formed. With a sharp tool I locate her eyes and mouth; with a little ball of clay I suggest her nose. I also sketch and locate proportions for her breasts (7).

DEVELOPING THE HEAD AND FACE

Now I believe that I should cover the lower part of the figure with plastic. The clay is beginning to harden, and I don't want the drying out to go too far. Also, I want to learn what sort of face she will have, because her expression will influence her posture and clothes (8).

To develop her face, I use both a flat, wooden tool and a sharper metal one for the incisings (9). The head is turned frequently, so that all sides emerge at about the same time. I develop the back of the head and work on the shape of her hair and her ears (10). By the way, I allow the newspaper to stand out from the top of the head so that I will not forget to provide a venting on the top of the figure (11).

BALANCING FORMS

With a few incisions I indicate the way I would like the girl's hair to fall across her forehead (12). I provide an earring for her left ear. I do this partially because the weight of the hairdo is causing the head to list to the left; the earring tends to strengthen the neck area and arrests the lean.

It is time for lunch. To prevent rapid drying, I wrap the figure somewhat loosely in plastic (13).

After lunch, I uncover the girl to her waist. I give her a breast and prepare to give her another (14). Now I consider the style of the evening dress (15). I decide that it will be cut to the waist, rather like one I might have seen in the rerun of an old movie. I confess to an infatuation with the films made in Hollywood in the twenties and thirties. They were—especially by present-day standards—nicely civilized. The actors and actresses had distinctive characters—they weren't types. In the better films they behaved with a mixture of wit and elegance, suavity and decorum which I find pleasant indeed. Bebe Daniels wore wonderful clothes, and so did Kay Francis, Carole Lombard, and Harlow.

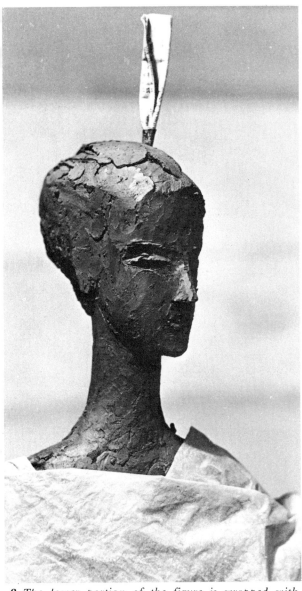

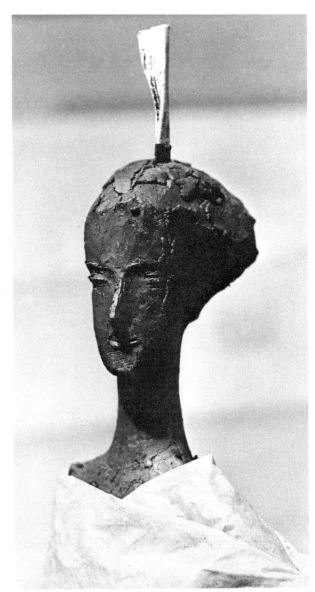

8. *The lower portion of the figure is wrapped with plastic to prevent it from drying too rapidly.*

9. *I begin to develop her face.*

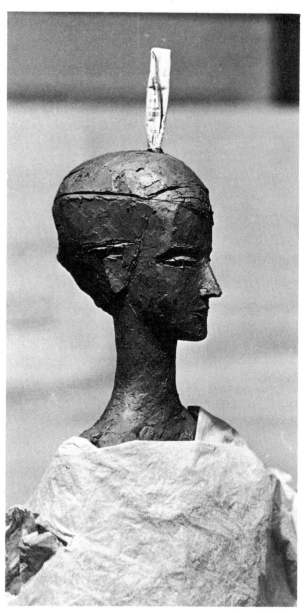

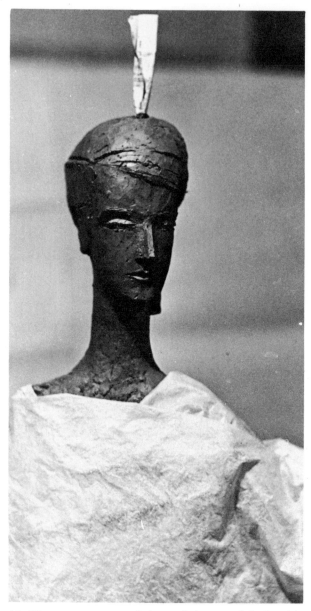

10. *Here I delineate approximate positions for her hair and ears.*

11. *The armature extends beyond the top of the head to remind me to provide a venting.*

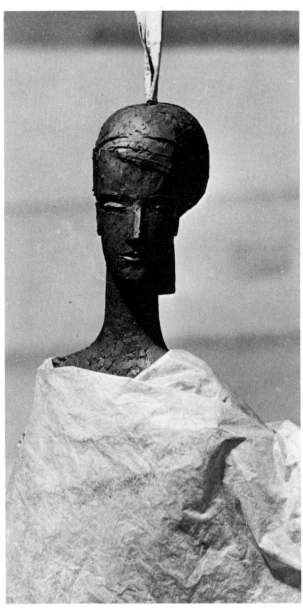

12. Here I arrange her coiffure.

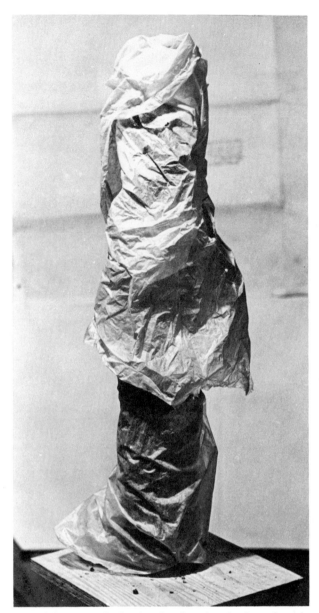

13. While I break for lunch, the clay is draped with plastic to slow down its drying.

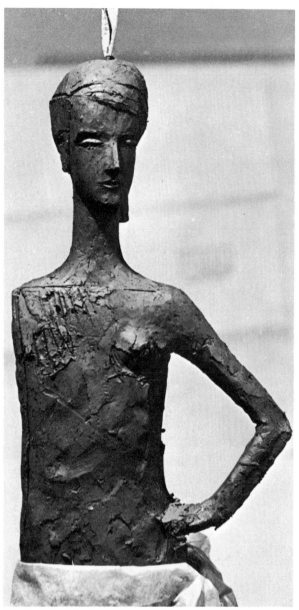 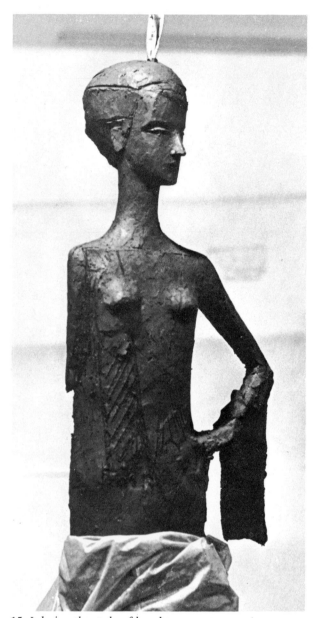

14. Here I add a breast to my figure. *15. I design the style of her dress.*

I form a drape of some sort to fall from her arm (*16*), and place a corsage (*17*) on her left shoulder (echoes of my high-school prom: the required gardenia!).

I feel that perhaps the draping should wind about her upper arm as well (*18*). It helps to set up a secondary form to the left of the larger one provided by the girl's body (*19*).

Now I return to the head (*20*). I am worried about its surface; it is too smooth, too nursed along. I therefore gob clay along the left side of the head and roughen the hair. I define her eyes and cut in the pupils. I sharpen the detail around her ear and earring.

The lips are made more precise. I take some care with the shape of her nose and the round forms which create her nostrils. Building out her hair away from her head has been a good idea; it allows for a much darker lateral shadow (*21*).

The piece is now finished, and I put it aside.

LOADING THE KILN

After the girl has dried for a while in my studio, I put her into the hot box. Then, when she is completely dry, I prepare to load my kiln. I decide to fire, because this piece has been the last of a series of sculptures which I have completed. Therefore, the kiln will be full.

I use a Model HF 30 gas-fired kiln made by A.D. Alpine, Inc., 11837 Teal Street, Culver City, California. I begin by erecting a shelf with fire bricks as its support to elevate the sculpture somewhat above the kiln floor. The kiln, I discover, is really a bit large for the pieces I have; I invite an abstract piece (one done by a friend) to share the firing (*22*). I shall still have a bit of extra space.

On the shelf, I place *The Girl Against an "F" Wall* (in this rear view the "F" appears as an "S") upon rollers so that the width of the wall will successfully suffer shrinkage.

I stand fire bricks one upon the other to arrange for the next level, and the top half of a piece entitled *Tom Mix* is put into place (*23*). He is balanced upon pieces of kiln furniture, so that the heat can circulate up into his hollowness. Next I position *The Head of an Italian Soldier* (*24*). Standing it upon saddles, I can also raise this piece from the floor.

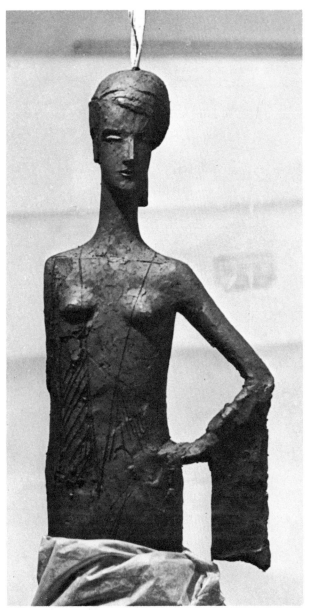

16. I create a draping in the girl's dress which hangs down from her bent arm and provides balance for the main form.

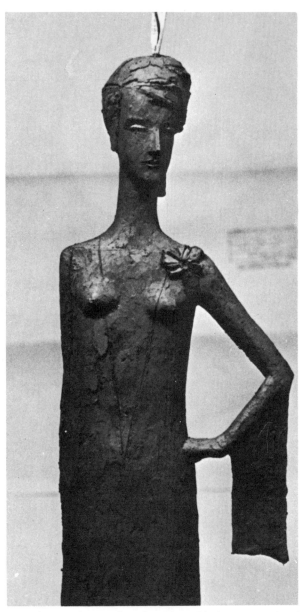 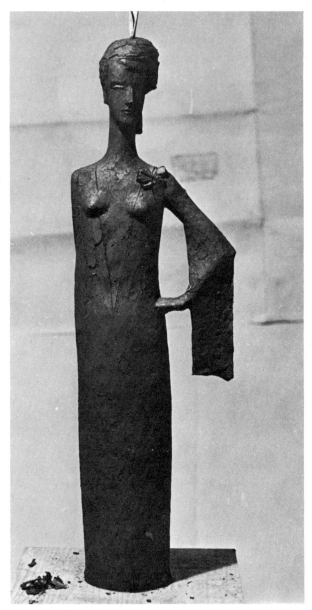

17. *The corsage on her shoulder adds just a touch of nostalgia.*

18. *I modify the draping to wind about her upper arm.*

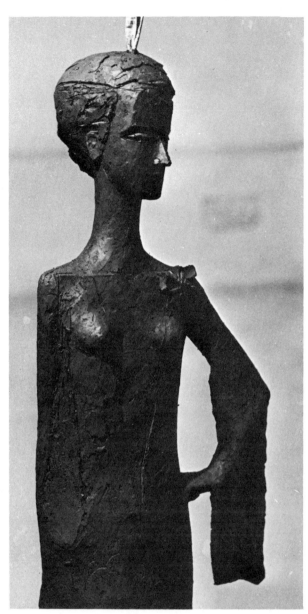

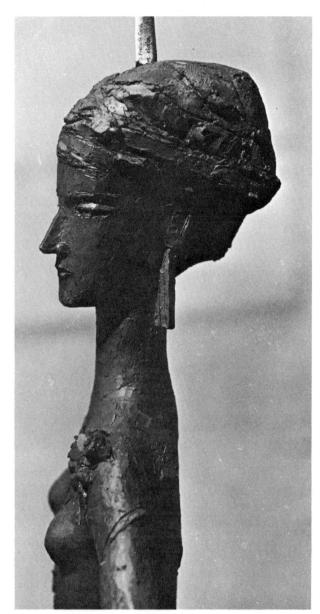

19. *The draping provides better balance for the main form.*

20. *I roughen the head somewhat to modify its overly smooth surface.*

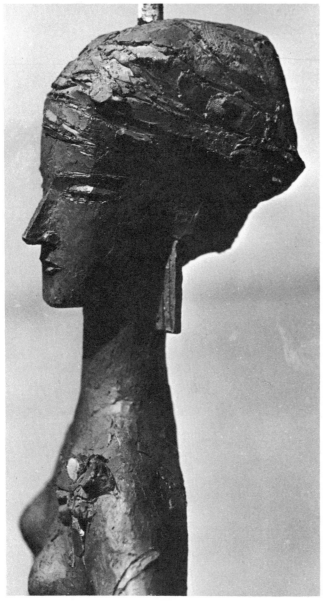

21. *By filling out the back of the head, both the sculpture's proportions and its shadow pattern improve. (See finished sculpture page 103.)*

Now I carefully balance a second shelf upon fire bricks. The legs of *Tom Mix* (25) are stood upon pieces of shelving; these pieces of shelving, in turn, I place upon rollers.

I should mention here that the figure *Tom Mix*, because the legs are so lean, was not done in one piece and then cut. The two sections were sculpted separately and will not be seen together until they are out of the kiln.

Girl in an Evening Dress I put into the kiln last (25) and balance it upon two fire bricks with the necessary space between them.

The cones are placed in position in front of the kiln's peepholes (26). The door is then closed and the kiln ignited (27).

KEEPING A LOG

I keep a log of the firing operation. It contains such information as the date, the sort of load, the speed of firing, and at what cone the kiln is to be fired (in this case Cone 4, with Cones 2, 3, and 5 used as guidance). The amounts of gas and air are entered in the log along with the position of the damper, the temperatures at the top and bottom of the kiln, and the temperature at the time of each observation. A facsimile of such a log appears nearby.

FIRING THE KILN

This firing is not without its troubles. The kiln is fired at 11:00 A.M.; at 6:00 P.M. it is left for the night with its damper full open. By then the temperature has risen to 425° F. at the top of the kiln and 650° F. at the bottom. The next morning, however, due to an interruption of the gas supply, the kiln has cooled down to 350° F. at the top and 300° F. at the bottom and has turned itself off.

By the end of the second day, I bring the temperature back through the 400's to 1300° F. at the top of the kiln and 1250° F. at its bottom. I turn the gas to a dial position of 3.6; the air remains constant at 50. During this second day, the dampers have been changed from full-open to half-open.

The next morning (the third day) at 8:15, the gas relays are opened to 5 and the kiln is further dampened. By 10:00 A.M. Cone 2 at the bottom of the kiln is bent. The temperature there is

Slow fire, Light load, Cone 4

Time	Notes	Gas	Air	Damp	Temperature° F.	
					top	bottom
11:00 A.M.	———	1.0	50	Full Open	250	250
4:30 P.M.	Left burner does not hold flame below 2½''	———	———	———	———	———
5:30 P.M.	———	1.6	50	Full Open	450	550
6:00 P.M.	———	2.0	50	Full Open	425	
8:30 A.M.	Kiln off and cooled down; both relays open	2.0	50	———	350	300
12:00 Noon	———	2.5	50	½ Open	850	600
2:00 P.M.	———	2.5	50	½ Open	1075	950
3:00 P.M.	———	3.0	50	½ Open	1125	1025
5:30 P.M.	———	3.6	50	½ Open	1300	1250
8:15 A.M.	———	5.0	50	1/3 Open	1850	1900
9:15 A.M.	———	6.0	50	1/3 Open	1925	1975
10:00	Cone 2 bent; no flame at damper Air cut back slowly to bring flame to kiln top	7.0	48	Opened slightly to clear flame at side ports	2000	2050
10:15 A.M.	Cone 3 down—bottom	———	———	———	2025	2075
10:25 A.M.	Flame at damper Cone 4 bent—bottom Cone 2 bent—top	———	38	1½ Open	2050	2100
10:45 A.M.	Off Cone 5—bottom Cone 4 bent—top	35	———	———	2075	2125

22. *I begin stacking the kiln with another piece of my sculpture,* Girl Against an "F" Wall. *At the left you can see an abstract piece done by a friend.*

23. *The top half of* Tom Mix *is located within the kiln.*

24. *I raise* Head of an Italian Soldier *from the kiln floor by placing it on saddles.*

25. *I establish a second shelf within the kiln and position the last piece, my* Girl in an Evening Dress. *You can also see the legs of* Tom Mix *at the left.*

26. *The pyrometric cones are placed to line up with the peepholes in the kiln's door.*

27. *The kiln is ignited.*

2050° F., 50 degrees above the temperature at the top of the kiln. To balance the temperatures, the air is cut back slowly, from 50 to 48, and at 10:25 A.M., to 38, to try to bring more flame to the top of the kiln.

At 10:15 A.M. Cone 3 at the bottom is down. At 10:25 A.M. Cone 4 also at the bottom bends, as does the top Cone 2. The temperature is 2050° F. at the kiln's top, and 2100° F. at its bottom. At 10:45 A.M., with the air at 35, Cone 5 at the bottom of the kiln bends, and so does Cone 4 at the top, and I shut the kiln off.

OPENING KILN AND ASSESSING RESULTS

Despite the irregularity of the firing, the sculptural pieces have come through in a satisfactory way.

The Head of an Italian Soldier is a bit darker in tonality than the rest, because it had been placed in the lower part of the kiln. As the log shows, the temperature at the bottom of the kiln came to 2125° F. as opposed to 2075° F. at its top. I do not object to the darkening, however; I content myself by brightening with paint the military cord and epaulet upon the soldier.

The Girl Against an "F" Wall is also left pretty much as it came from the firing, with the exception of the letters on the wall. The "F" and the part of an "O," the "S" on the back of the piece, the girl's pearls, her sweater, and the buckle to her belt are all emphasized with paint.

The two halves of *Tom Mix* are now joined together at his waist with epoxy cement. The joint is camouflaged with metal paste. I decide that I shall color this piece more highly since the movie cowboy, to me, is rather a peacock. I allow his ten-gallon hat to be white, as it should be, and contrast it with a red kerchief. I give his gun a pearl handle, and I complicate his black vest with white decoration—including a large scroll on its back. The conchas upon the fellow's chaps are made more silvery, and then I embellish them with red stars.

Then I decide that *Girl in an Evening Dress*, perhaps because the aura of the night can be less "honest" somehow than the day, should also have a more richly-colored patina, as does *Tom Mix*. I use paint to bring the dress to an ultramarine blue and to whiten the gardenia. A few sequins are added to the draping of the dress. Lastly, I bring up the color in the girl's earring.

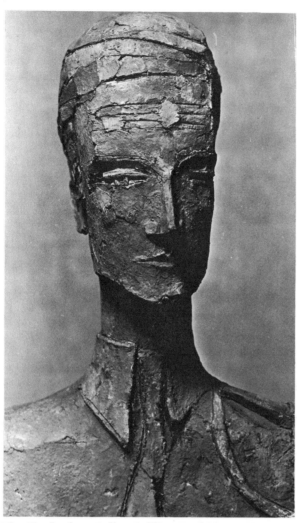

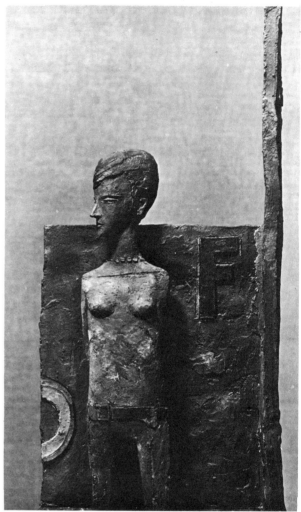

The Head of an Italian Soldier. Fred Meyer. Courtesy Midtown Galleries, New York.

The Girl Against an "F" Wall. Fred Meyer. Courtesy Midtown Galleries, New York.

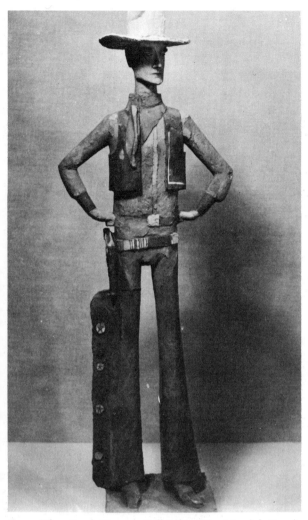

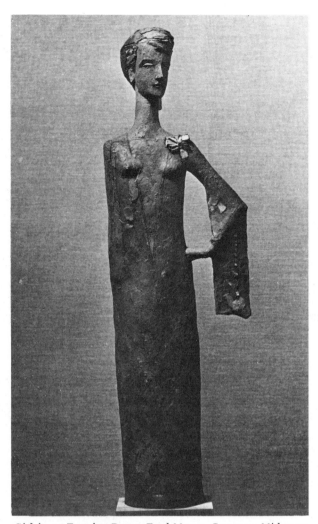

Tom Mix. Fred Meyer. Collection Mr. Merrick Lewis, London.

Girl in an Evening Dress. *Fred Meyer. Courtesy Midtown Galleries, New York.*

1. Cowles fits two plaques of clay together.

CHAPTER TEN

Hobart Cowles: A Non-Representational Technique

Hobart Cowles, a professor at the School of American Craftsmen of the Rochester Institute of Technology, works in a non-representational way. His sculpture is meticulously worked and soundly crafted. He usually balances a series of honed organic shapes against surprisingly natural eruptions. The results often fuse this apparent contradiction into a unity, and provide us with the pleasure of harmony, the successful completion of a drama which finds opposites to be related.

BUILDING FROM PLAQUES

Upon a pad of burlap, Cowles begins this piece by shaping a second plaque of clay about a first (1). He works on burlap because he enjoys its texture. By aerating the clay, the burlap allows it to be more flexible for a time. He keeps a bowl nearby containing slip, his thin mixture of water and clay.

His tools are humble and few (2). They include a sharp-pointed, thin-bladed knife, a tool tipped with a dozen nails which is used for scraping, a file, and an odd bit of screening.

He seams his edges in the following manner:

by using the second tool, the one with the nails, he scars the abutting surfaces; then he brushes these scars with slip, and presses them together (3).

ERECTING CARDBOARD SUPPORTS

As you've probably noticed, Cowles begins the sculpture horizontally. After allowing time for it to firm, he now stands the piece upright (4).

As he continues, Cowles decides to erect a corrugated cardboard form in order to build out a cantilever of clay. He cuts the cardboard with the knife, and carefully firms up the projection with a roll of the same cardboard (5).

You will notice here, too, how the texture of the burlap has been left on the clay. Cowles stands the foot of his sculpture upon burlap, rather than the plaster bat, to prevent the plaster from absorbing the clay's moisture.

ATTACHING PROJECTIONS

The area to which the cantilevered surface will be attached is scarred and painted with slip (6). Next (7) Cowles attaches the projection and

2. *Cowles uses a few simple tools (left to right): a sharp, pointed knife with a thin blade, a wooden tool tipped with nails, a piece of screening, and a file.*

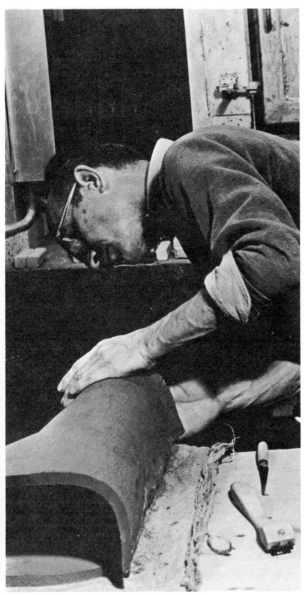

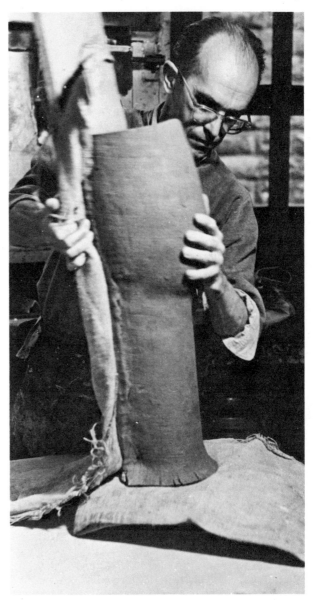

3. After scarring its edges, Cowles seams the clay.

4. After allowing the sculpture to firm, he stands the piece upright.

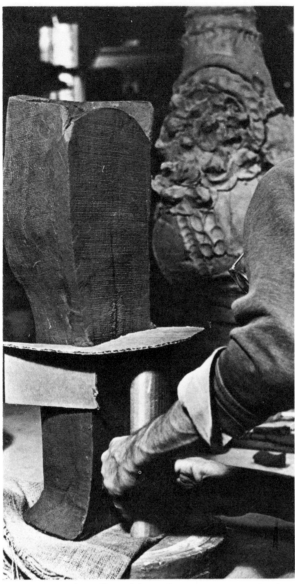

5. *Corrugated cardboard is used to support a projection in the clay.*

6. *A scarred joint is painted with slip in preparation for the projection.*

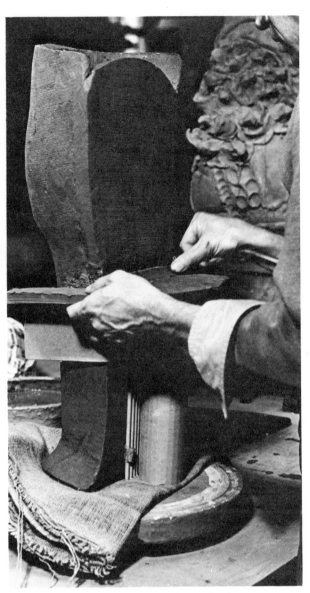

7. *Cowles attaches and secures the projection.*

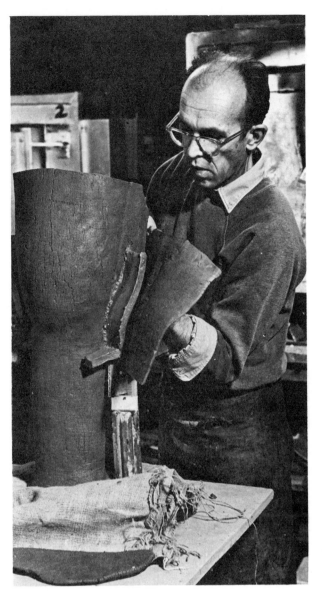

8. *Another plaque of clay is fitted around the canti-levered projection.*

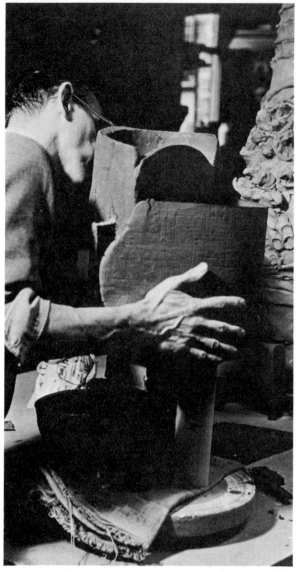

9. In the background you can see a student's sculpture which illustrates an interesting variation in technique.

firms it down with a noodle-like roll of clay which he presses flat, much as a glazier would putty a window.

Cowles brings a large plaque of clay about the rim of the cantilever and prepares to affix it to two wings he has built onto the piece (8).

THE COURAGE OF SPONTANEITY

The large sculpture seen behind Cowles (9) was done by one of his students. It stands in its bisque stage. Although impetuous—seemingly slapped together with pancakes of clay, loops of wet clay ribbons, clay twists, thumbprints, and uneven pinches—it is still sensitively done and has a nice exuberance. It is, of course, a tribute to Cowles as a teacher that he tolerates and encourages approaches to sculpture which are so temperamentally distinct from his own.

TOPPING OFF AND REMOVING SUPPORTS

Cowles tops the encircling form. He introduces a significant contrast by making a natural vulva-like slit, or incision, in its top (10). Cowles builds a ledge within the top of the main encircled form to prepare it for its cover. When this has been done, Cowles takes a break; the piece needs to harden.

When he returns to work, he removes the cardboard support which had been erected to receive the cantilevering and act as the base for the broader form in the sculpture (11). He now uses his tool with the nails to scar the clay where the next leg is to be placed.

REFINING THE SURFACE

You will notice that he has scraped the surface of the sculpture to erase and to modify the texture of the burlap. Continuing his preparations for adding legs, he scars and then moistens the underside of the cantilevering (12, 13). Now the legs are inserted (14).

After the legs are positioned, the sculptor resumes his scraping of the surface. He first uses the scraper; for the softer surface he employs the bit of rolled screen (15).

Cowles now places the piece horizontally upon scraps of foam rubber and burlap (16). This will allow Cowles to sand and refine any

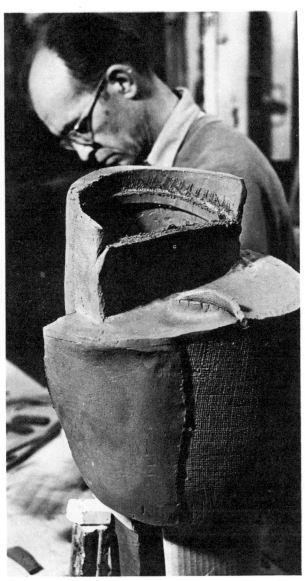

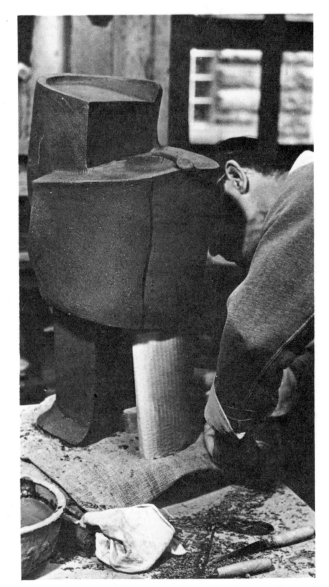

10. Cowles introduces a surprising, contradictory slit in the top of the piece.

11. The cardboard support beneath the cantilevered form is removed.

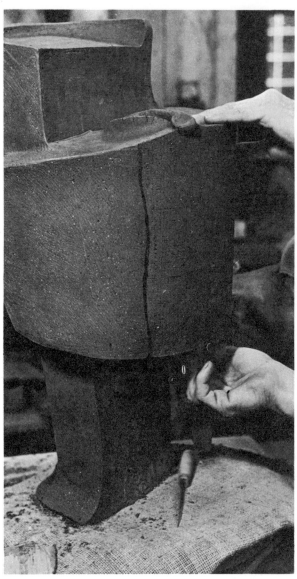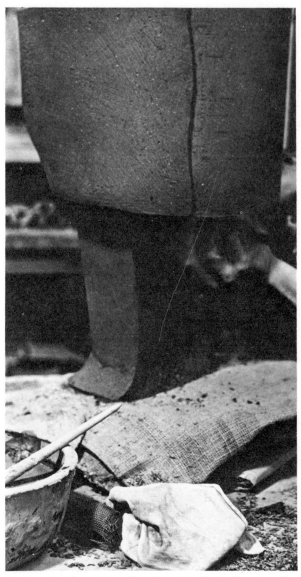

12. *The underside of the cantilevering is first scarred to prepare it for receiving the legs.*

13. *Cowles also paints the clay with slip before inserting the legs.*

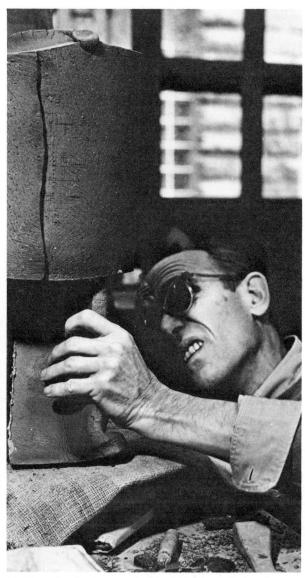

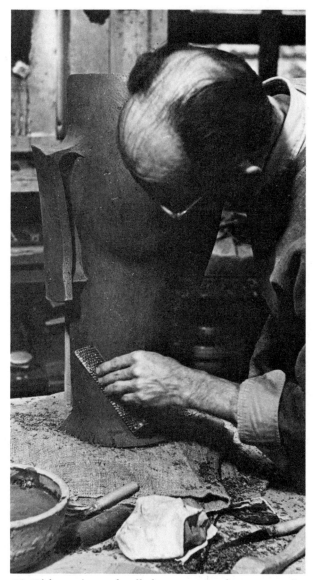

14. *Here Cowles inserts the legs into the main section.*

15. *With a piece of rolled screen, Cowles scrapes the clay's surface to erase the texture created by the burlap.*

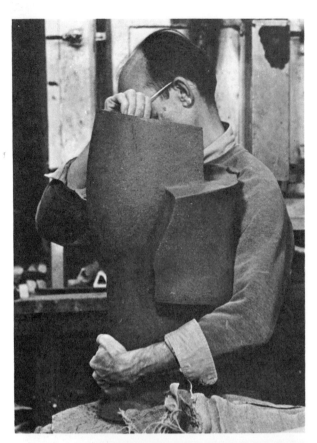

16. *For easier access, the piece is laid horizontally upon foam rubber and burlap.*

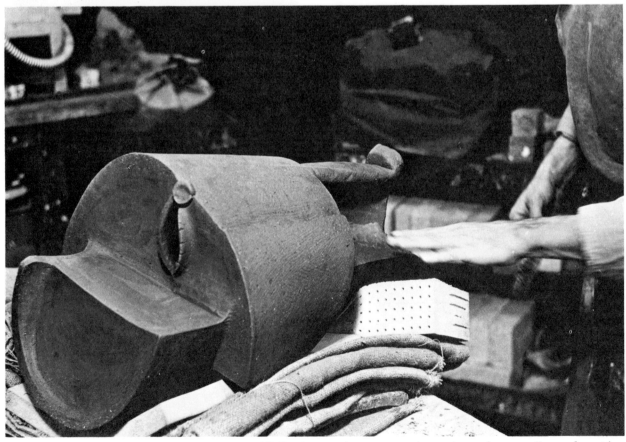

17. *Cowles continues to work on the surface, sanding and scraping.*

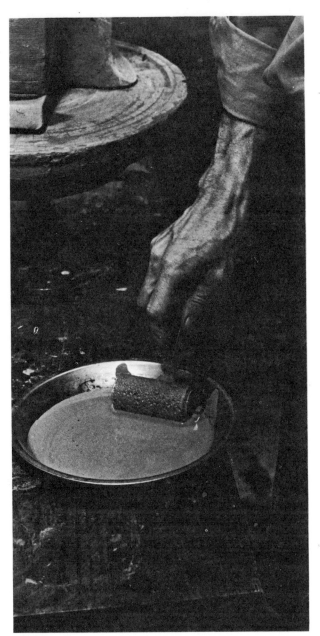

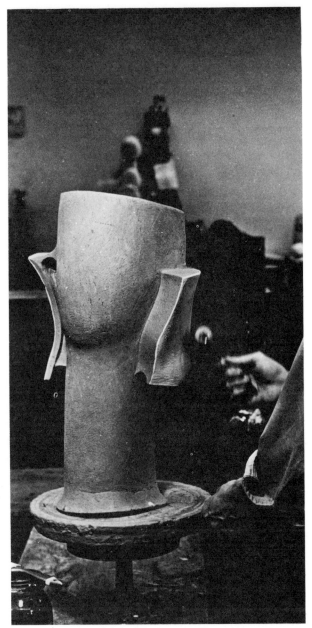

18. While the clay is "leather hard," Cowles applies an engobe or slip.

19. The slip is applied in an overlapping fashion.

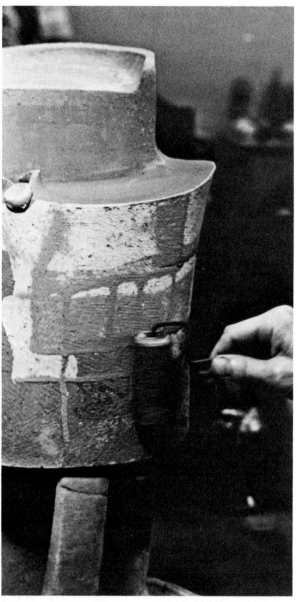

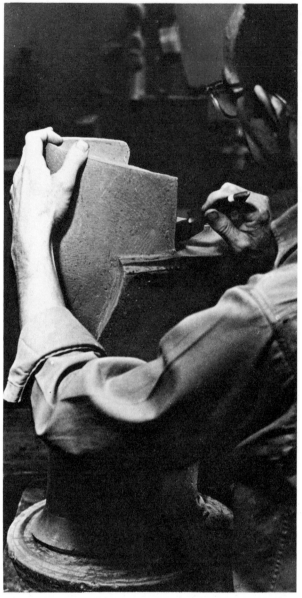

20. *This overlapping type of application enhances the slip's effect.*

21. *A brush can also be used to apply slip to areas not easily accessible with the roller.*

22. *(Right) Here is the finished piece, as yet untitled.*

surfaces that he could not reach while the sculpture stood in an upright position (*17*). Notice, however, that the vulva-like form remains relatively crude, its walls cracked, for contrast.

Before the sculpture has hardened too much or dried, it is in the useful "leather-hard" state. At this time, Cowles mixes a colored oxide with some of the clay from his piece and applies this engobe, or slip, to the sculpture's surface with a roller (*18*). The overlapping that the roller creates and the dripping that takes place can enhance the effect of the engobe if the application is done with artistry (*19, 20*).

Where the roller proves to be clumsy, or if you should want a different effect, a brush or a spray can be used (*21, 22*).

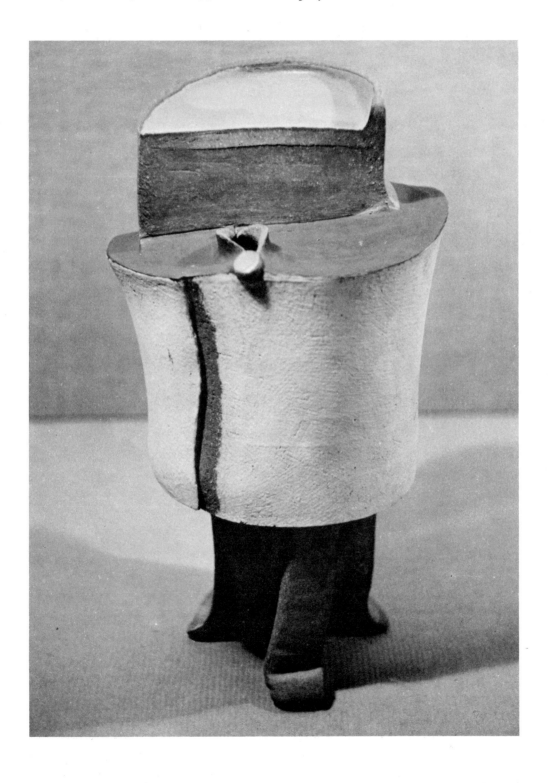

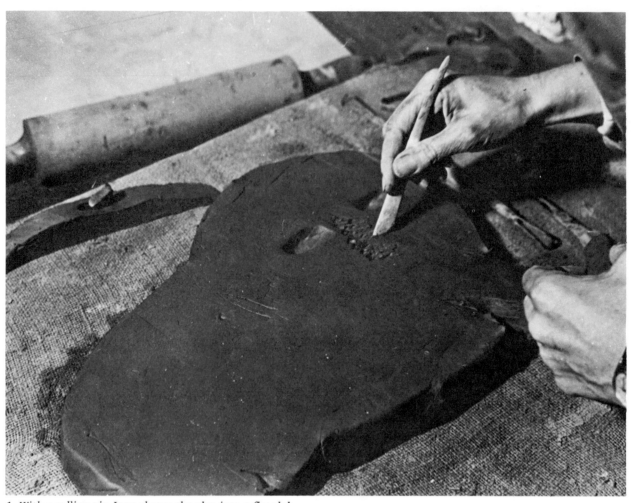

1. With a rolling pin Joan shapes the clay into a flat slab.

CHAPTER ELEVEN

Joan Frantz Meyer: An Innocent, Ingenuous Technique

My wife sculpts on her dining room table, in between housekeeping and caring for our two children. And yet, despite the "hobbyishness" of the operation, she manages, I feel, to imbue her work with qualities which need to be—but seldom are—in the best ceramic sculpture.

Count Leo Tolstoy, in writing about a work of art, has said that three qualities are essential: simplicity, spontaneity, and ingenuousness.

How many pieces of ceramic sculpture fail to meet these criteria. How much is contrived and imitative—with one eye on the show and the market—rather than spontaneous and simple. How much of it is precious, "stylish," sentimental, and naive rather than ingenuous.

BUILDING WITH SLABS

Joan's technique is obvious enough. You can see how she rolls a slab with a rolling pin, the same one she uses when she makes pies (1).

She does animals as well as heads of Michael and Sarah, our children. This piece will be a lion. She cuts off its body with a sort of basic cookie-cutter shape, puts on a nose, and punches in the lion's two eyes (2).

By the time she draws in his chops (3), it is already no longer a slab of clay to Joan but a being. "He wants to smile," says Joan while using a wire-ended tool. "I do expect he would like having bangs" (4).

Now having his face, Joan's lion then sits up and curls himself into a resting position (5).

Yet, although personified, to Joan the lion must always remain enigmatic. That is, while being pleasantly pet-like and charming, he is *also* only clay; he must know his place. The lion's form will retain the essential shape of the clay slab from which it has emerged (6). Joan then feels that her lion needs more of a head and more mane (7).

Joan likes bulky, massive forms. I expect this solidity that she introduces provides a good foil for her more whimsical touches: the curls, the doe-eyes, and the smile. The roughness of her bulky forms is necessary to prevent her childlike affection for her animals from slipping into saccharinity.

With a sharp, pointed tool, she scars the clay surface in preparation for attaching a haunch [seen unattached in the foreground (8)]. After the haunch is set in place, a few quick strokes

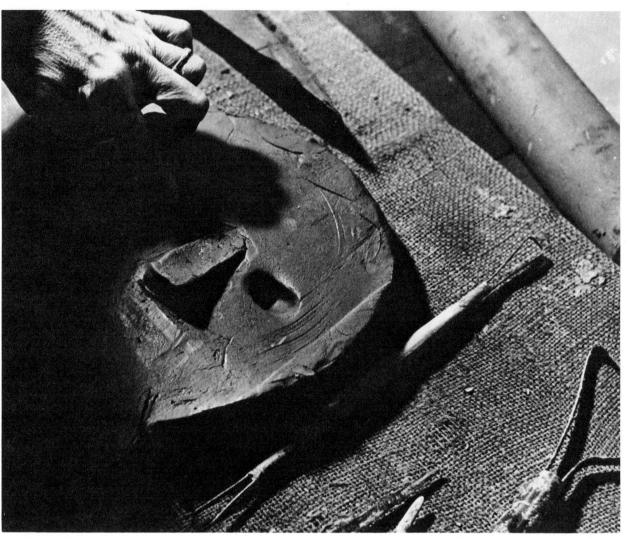

2. The lion's body is cut out in a cookie cutter fashion; eyes are punched into the slab with the fingers.

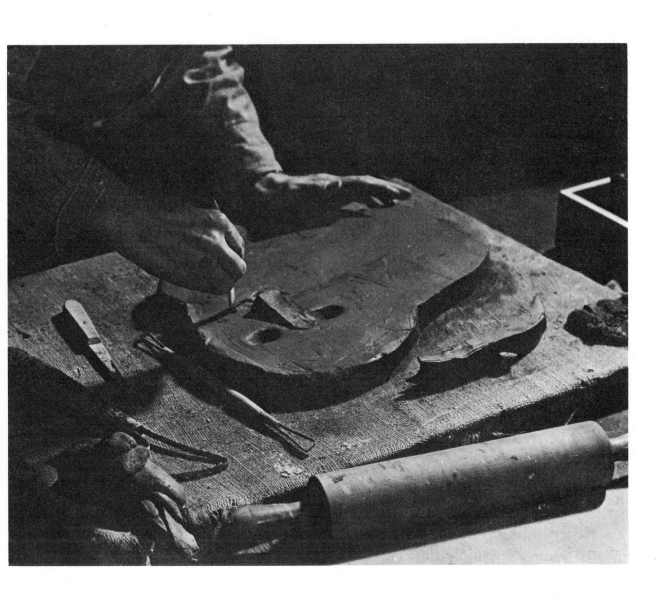

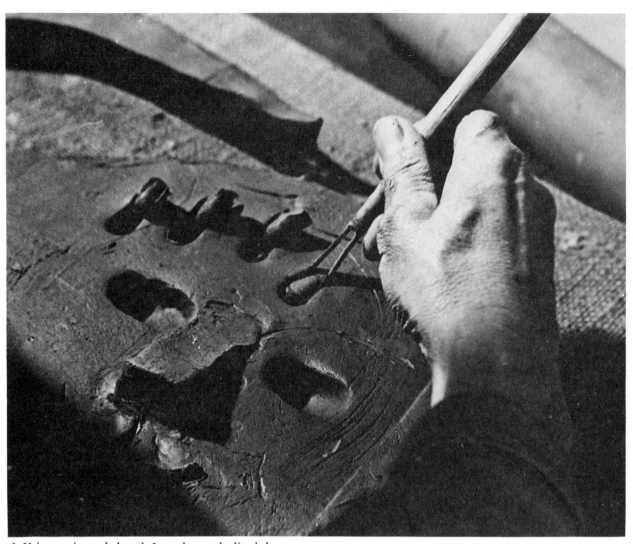

4. Using a wire-ended tool, Joan shapes the lion's bangs.

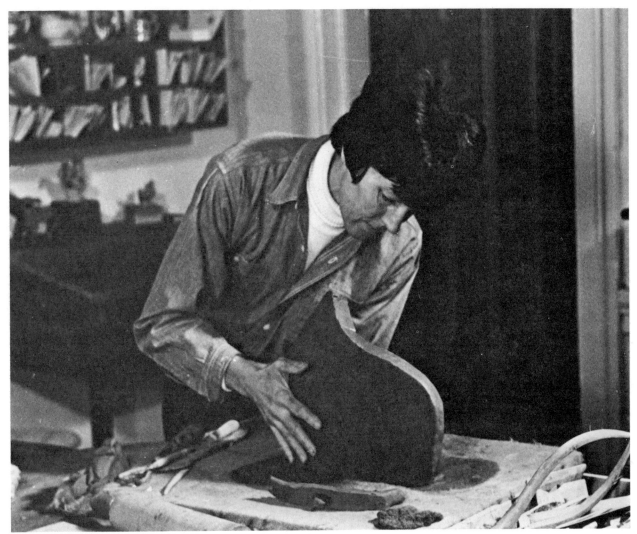

5. *Setting the lion upright, she decides that he should curl up.*

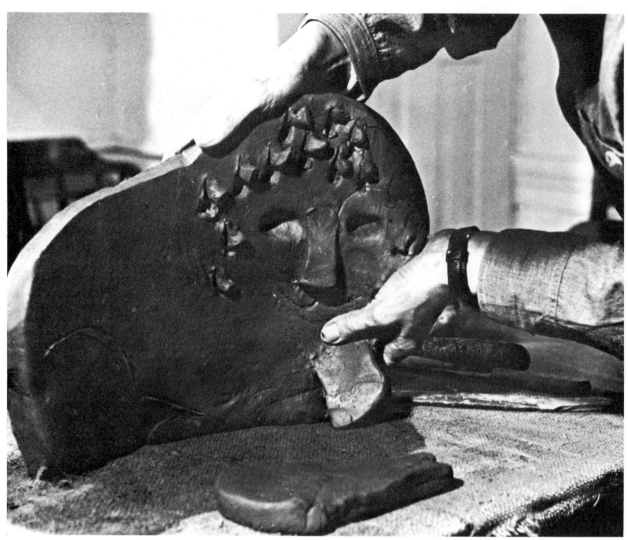

6. *The lion's body retains the look of the clay slab.*

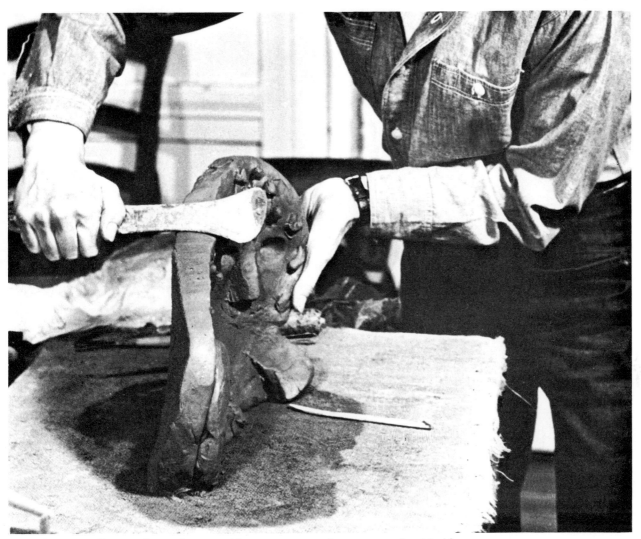

7. *With a large, flat wooden tool, Joan adds more mane and accentuates it with ridges.*

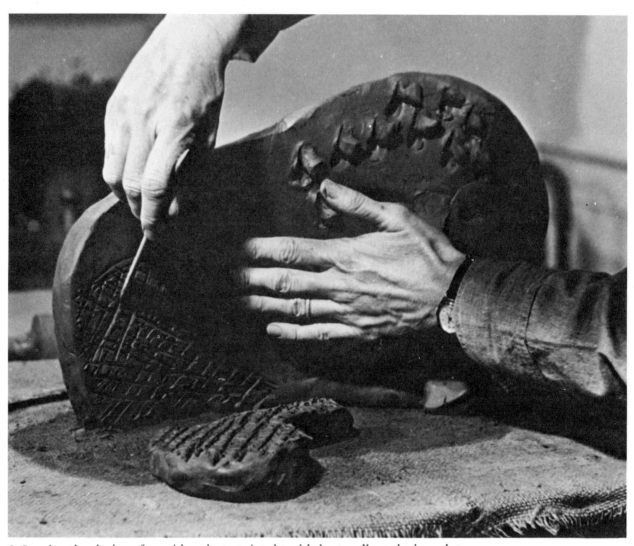

8. *Scarring the clay's surface with a sharp, pointed tool helps to adhere the haunch to the main piece.*

begin the lion's front paws (9). More strong strokes turn the initial gouging into a more defined and "respectable" mane (10).

ADDING DETAIL

This is enough for a morning's work. The messier work is finished; Joan needs to dress, because there is shopping to do.

Later, Joan works on refining the lion. By patting him with a stick, she thickens and firms the lion (11). She puts eyeballs within his sockets, forms his lids, and combs his mane (12). With broad strokes of a serrated tool, Joan decides to have the lion's front legs crossed more jauntily. His paws are given more detail (13).

"There," says Joan, "I like him now. He looks fetching."

PREPARING A GLAZE

The lion is fired to bisque. Then Joan puts a blue copper matt glaze on his mane and returns her lion to her kiln. The blue copper matt glaze was taken from a recipe in the Carlton Ball book, *Making Pottery Without a Wheel*. The recipe is as follows:

barium carbonate	600 grams
nepheline syenite	1350 grams
Kentucky Special ball clay	140 grams
flint	160 grams
copper carbonate	70 grams
lithium carbonate	70 grams

Joan has used this glaze with and without a blue slip painted on the clay underneath. The glaze without a slip produces quite a bright blue-green color. Where slip is painted underneath, it becomes a stronger purpley-blue. On this lion Joan painted a black slip under the glaze on parts of the mane, thus playing down the intense color in some parts. Also, the lion was fired in a reduction atmosphere at a Cone 6 temperature. The reduced kiln produced a warmer blue color than an oxidized one.

ADDITIONAL SCULPTURE AND THEIR GLAZES

Joan's *Cat on a Fish* is again done boldly, yet has many subtleties and a good deal of charm. Notice, for example, the delicacy of the cat's whiskers and the care given to the direction of the cat's fur.

The scales and ribs of the fish are done more hastily and a bit more grossly, because the fish is of secondary importance. The cat, in this case, is the thing. Joan explains her technique:

"No glazes were used on this piece. I brought out the fur-like texture of the cat by pouring white slip over the bisqued piece. Then with a sponge I rubbed the slip off again. The remainder filled all the little cracks and created a fur-like appearance. Blue slip was painted on the supporting fish base but *not* rubbed off again, because it is a strong blue."

The blue stoneware slip, which can be fired successfully from Cone 5 to Cone 9, is made as follows:

rutile	80%
cobalt oxide	10%
frit 3124	5%
ball clay	3%
gum arabic	2%

The white slip, which can also be used for stoneware, was fired at Cone 5 to Cone 9:

flint	55 grams
Bainbridge feldspar	15 grams
ball clay	10 grams
frit 3110	15 grams
bentonite	6.5 grams
opax	6.0 grams

The cat's eyes are a bright, luminous yellow. They provide contrast to the unglazed clay of the cat and accent the blue of the fish. The eyes were first painted with white slip; then a dab of straight Naples Yellow Colorant was put on over that.

The *Green Sheep* is covered with a deep green-black metallic glaze, along with glossy white accents. Here is the recipe for the green-black metallic, which fires successfully from Cone 04 to Cone 5:

frit P545	60.0 grams
Gerstley borate	33.0 grams
spodumene	87.0 grams
kaolin	39.0 grams
tin	15.0 grams
copper carbonate	10.5 grams
gum arabic	3.0 grams

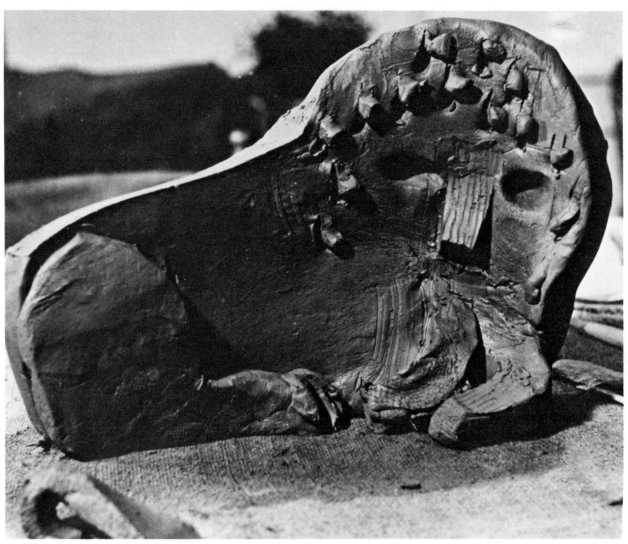

9. With a few quick broad strokes of a serrated tool, the lion's paws are quickly defined.
The branch is now attached to the main piece.

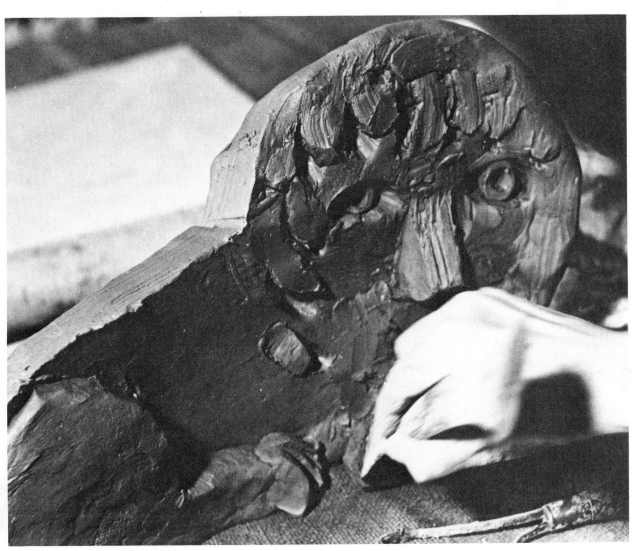

10. Strong strokes emphasize the mane.

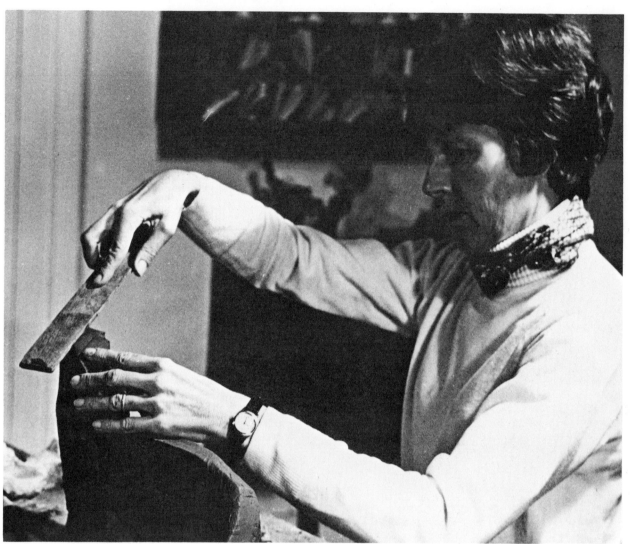

11. Patting with a flat stick firms up the clay.

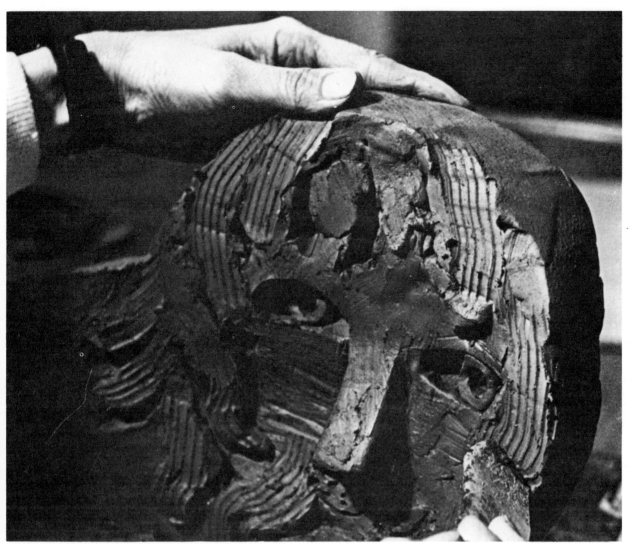

12. Joan textures the lion's mane with a serrated tool.

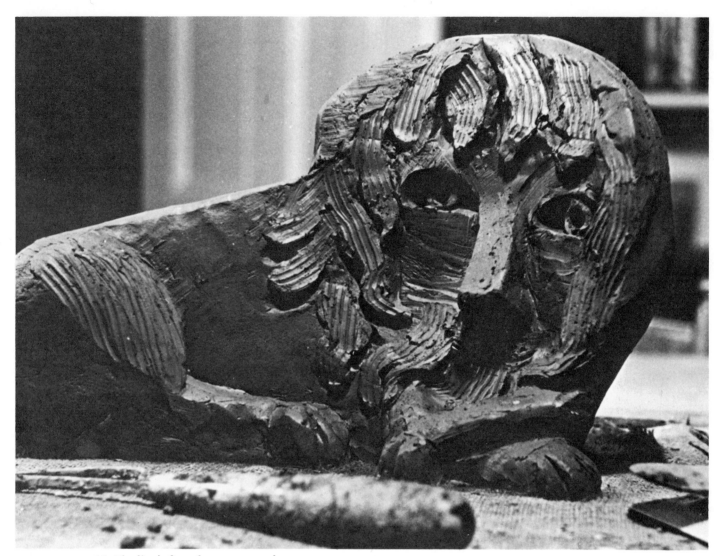

13. The lion's front legs are crossed.

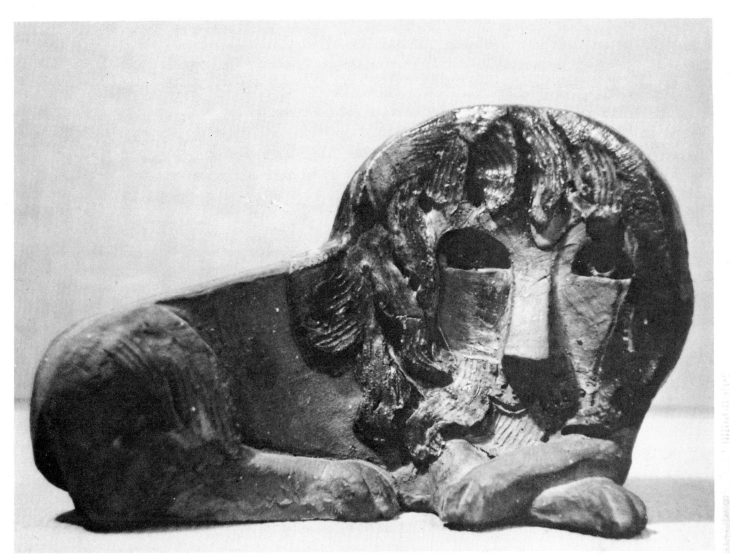

Lion with a Blue Mane. *Joan Frantz Meyer. Collection of the artist. Here is the lion after its second firing.*

For *Lion on the Roof Tile*, the general shape of the lion is made by pressing clay into a rounded rectangular plaster mould. Onto this rectangular form Joan adds an open bowl shape of clay for the head. Jutting outward from this, she attaches a long nozzle form for his nose. To Joan, the lion seems to be looking down from a height, so a piece of clay is shaped into a roof tile for him to perch upon. Joan paints red iron slip on this roof tile. Further embellishments are open circular pieces of clay, suggesting a curly mane.

Since earthenware clay has been used to make this lion, the piece needs only a low firing. Since the clay color becomes richer at a higher temperature, the yellow glaze she settles on is also higher than needed. The recipe for this iron yellow matt glaze (Cone 5) follows:

frit 3191	34.0 grams
lithium carbonate	5.0 grams
kaolin	39.0 grams
flint	20.0 grams
zinc oxide	23.0 grams
tin oxide	5.0 grams
black copper oxide	.5 grams
red iron oxide	7.0 grams

This glaze is poured on and flowed over the head, chest, and part of the lion's back. Joan then pours blue slip on half of the face and the eyes for contrast. The piece is fired at Cone 5 in a reduction kiln, which makes the clay a little darker and the glaze a little richer than an oxidized kiln would have produced.

The red stoneware slip used on the roof tile base consists of the following:

rutile	45%
red iron	45%
frit 3124	5%
ball clay	3%
gum arabic	2%

The earthenware clay used for this piece has a standard low-fire body, firing between Cone 05 and Cone 5. It is made of the following material:

Cedar Heights Red Art clay	200 pounds
Kentucky Special ball clay	25 pounds
North American fire clay	50 pounds
bentonite	7 pounds

In Joan's sculpture, *Small Tabby Cat*, the cat's brown and white stripes alternate between a white stoneware slip (to which a little rutile has been added for warmth) and a shiny brown Albany slip. The cat has touches of blue stoneware slip on the face. Its big yellow eyes are Naples yellow straight from the jar—undiluted—with only a tiny amount of gum arabic mixed in to adhere it to the surface.

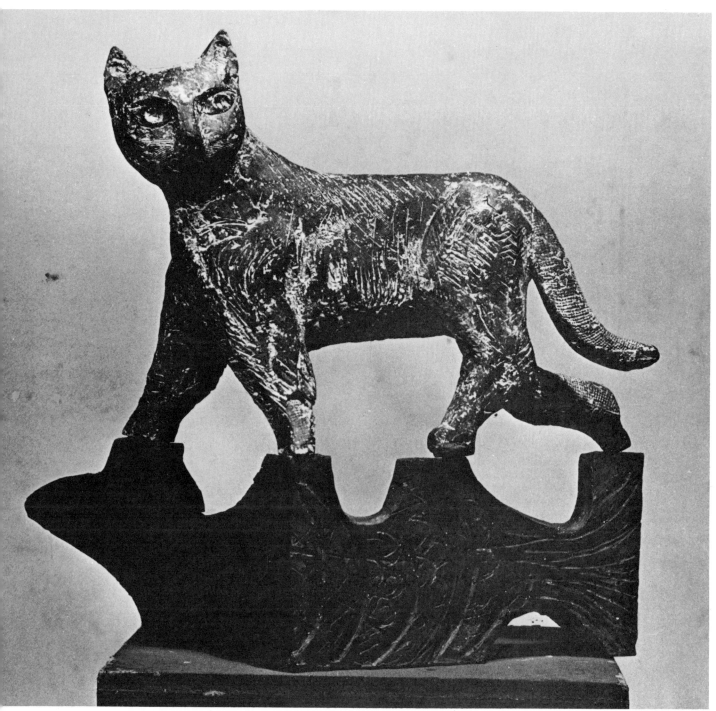

Cat on a Fish. *Joan Frantz Meyer. Collection of the artist.*

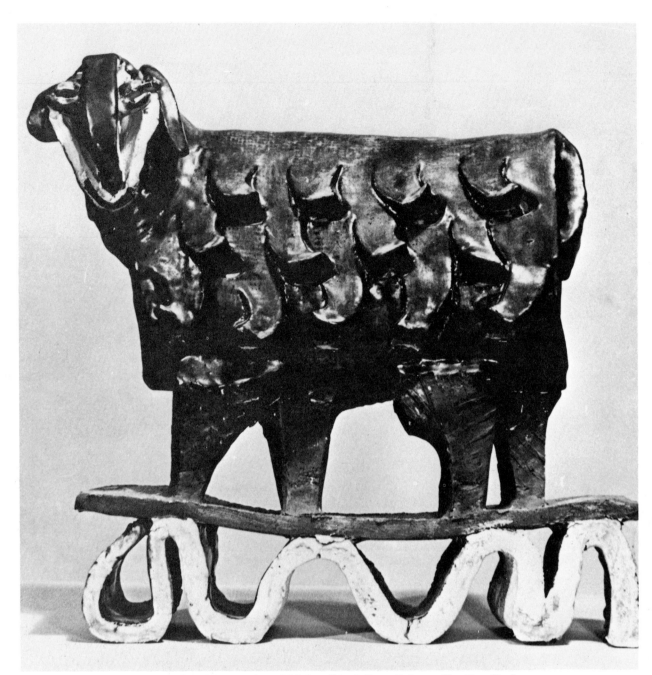

Green Sheep. *Joan Frantz Meyer. Courtesy The British Landing Gallery, Pultneyville, New York.*

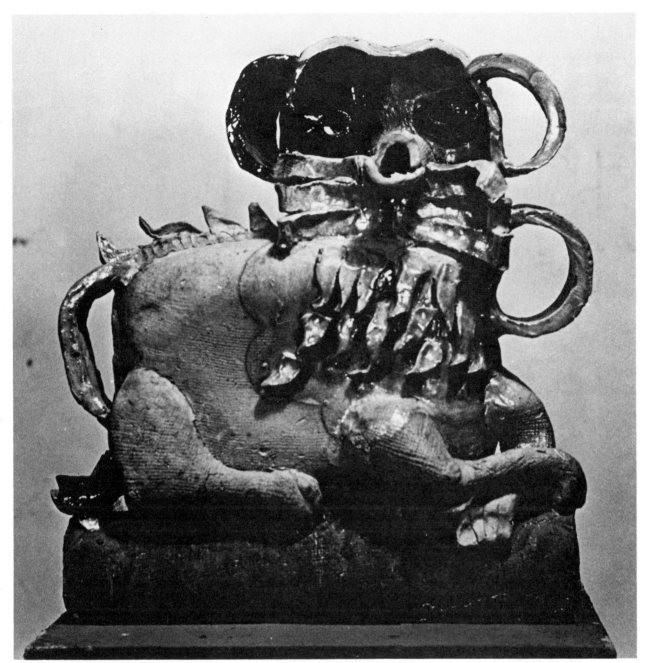

Lion on the Roof Tile. *Joan Frantz Meyer. Collection of the artist.*

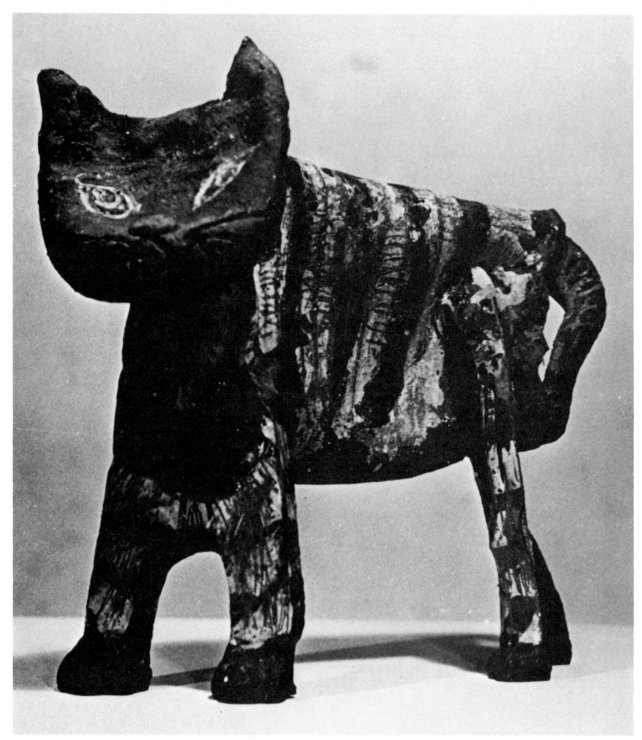

Small Tabby Cat. *Joan Frantz Meyer. Courtesy The Three Crowns Gallery, Pittsford, New York.*

The Presentation

Assume a work of sculpture is finished. It has been conceived in, let us say, joyful detachment; it touches the heartstrings. It contributes to life's need for richness, for completeness, for spiritual satisfaction, and for tactile, visual, and emotional pleasure.

Perhaps it is only a humble little "near-nothing," yet you have given it birth; it is your own and deserves to be properly mounted

LIGHTING

Bad lighting can destroy the effect of a good piece of sculpture. The painstaking adjustment of light is as important when displaying sculpture as it is in the portrait studios of Josef Karsh and Fabian Bachrach. The man who sits for these photographers can expect a more flattering result than he would obtain if he were photographed in a photo booth or by a fellow who knocks out chauffeur/passport shots. So, too, sculpture lighted with a meticulous balance of angles, intensities, and tones will be presented more effectively than merely by placing it haphazardly.

Most sculpture requires a heavier top light, with minor light at the front and the sides. The shadows deepen when the top light is stronger than the light from the front; in the reverse case, they wash away.

Of course, heavy light directly overhead usually renders the shadows overly deep. Generally, the major light should be slightly towards the front, but quite above, the sculpture. There should also be a series of "fill-in" lights at the front and the sides (one side somewhat brighter than the other to bring out the piece's volume) and, finally, a light directed upon the background wall to provide a slight silhouette.

This, incidentally, is a recommended lighting arrangement for photographing sculpture as well.

KINDS OF LIGHT

The best lights for displaying ceramic sculpture are incandescent; the worst (allowing for my prejudice) are fluorescent. I prefer the normal bulb shielded within a spot reflector or a baffle screen to prevent it from shining into the eyes of the viewer.

General Electric makes a spotlight bulb with a silvered neck to provide a built-in reflector. However, its lack of baffling or shield is a draw-

back, because it is quite difficult to use without setting up places where the viewer is blinded. You can, however, obtain a set of "barn doors," or blinders, which mount around a bulb such as this and can provide screening.

Natural light has its place, of course. Sculpture displayed indoors near a window can be illuminated by some incandescent bulbs to provide stability while exploiting the changing light of the sun. This can be a pleasant effect.

Pieces lit by the sun alone suffer moments of relative unattractiveness. But the sun, for some reason, seems more sensitive to sculptural nuance than some people with spotlights. So you can surrender your sculpture to the sun with some confidence.

Ceramic sculpture is placed outdoors at its own peril. It can break in the cold as ice forms in crevices and cracks; some of its surface paint can fade and wash away. Then there are the new vandals, the crude ones, who go about destroying what is beyond them, out of desperate spite.

MOUNTING

Certain pieces require mounting to give them more presence. My *Girl in an Evening Dress* required a base to bring her to a full-length proportion from her head to what would be her feet.

Although I have experimented with marble, I believe hardwood is the best base for ceramic. I prefer to work in walnut, mahogany, or ebony because these woods are relatively soft and beautifully colored. I have used walnut for the base of my *Girl in an Evening Dress.*

I buy planks of these woods, roughly 7' by 2" thick. I run the wood through a planer to smooth its two sides and also to remove any warping. Then the edges are planed with a table planer.

Next, the plank is sectioned with a crosscut saw to the rough height of the base. Several of these sections are then glued together, until the stack reaches the required depth. I cover both wood surfaces before joining with casein glue (Elmer's) and then clamp them together.

It takes about an hour for it to set, but I let the clamps remain for somewhat longer, just to be sure of the bond. I then cut the block to its

final proportion on a band saw, and sand it with a belt sanding machine using a coarse and then a medium belt. I complete the procedure by sanding by hand with a fine piece of sand or emery paper.

I put several screws into the top of the block and cover these with a paste of Thoropatch cement (Figure 20). Thoropatch cement consists of a dry powder together with its activator. Then I wet the base and the inside of the hollow sculpture. I put more of the cement onto the walls of the sculpture's hollow and set it down onto the screws. I let the piece stand for twenty-four hours. Then I finish the wood base to bring out its richness.

I finish the base by applying several coats of raw linseed oil and allowing each coat time to sink in. I follow this with a final coat of boiled linseed. Before the boiled linseed turns overly tacky, I rub the surface with double-0 steel wool.

I have tried bases of plastic, as well as bronze, aluminum, and iron. The contrast, however, between the warmth of the ceramic and the coldness of these materials has made me hesitate to use them too often. Yet they do deserve consideration as bases.

PROPORTION

It is most important that the base for a ceramic sculpture be properly proportioned with regard to the size and character of the work. A skimpy base (one too flat or too high), one that is overly grandiose, or one that is even too solid and "sensible" can spoil the sculpture's appearance.

There are no "rules" or equations to follow when determining the proportions for a sculpture base. You simply need to make the right judgement. Your judgement can be aided, however, if you have several odd blocks of wood that you can place the sculpture upon. In this way you will be able to see the results before you decide upon your final dimensions.

PEDESTAL DISPLAY

The shape, height, and depth/width dimensions of a pedestal are very important, just as they are with bases. A piece of sculpture deserves to be

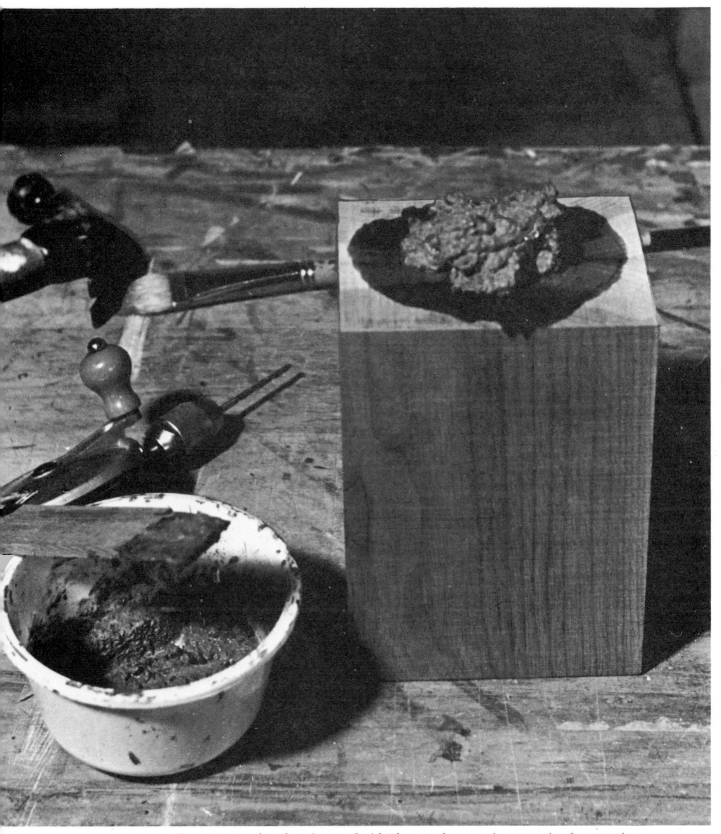

Figure 20. *A walnut base is coated with Thoropatch cement in preparation for mounting* Girl in an Evening Dress.

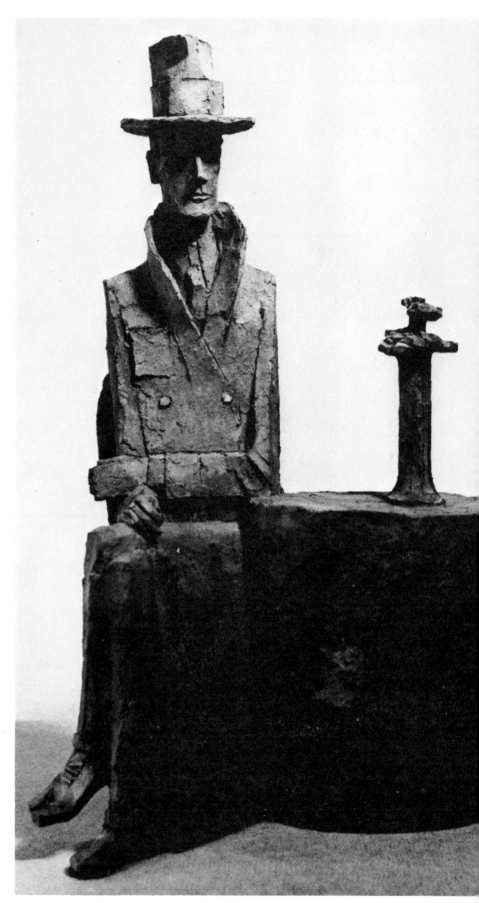

Cafe Goer. Fred Meyer. Courtesy Midtown Galleries, New York. This piece would suffer if placed upon a pedestal that was too high, because it would make the man seem too noble. On the other hand, a pedestal too low would make him seem overly mean. A pedestal of the proper height will make this Italian citizen appear to be what he is—an attractive combination of both nobility and meanness.

elevated to its correct height. How frequently a good piece of sculpture is humbled by being forced to stand on a table or pedestal which is too low! A sculpture so positioned loses all its force because you must look *down* upon it.

But a piece can also be placed upon a pedestal which makes it too high; it may even assume an arrogance which is not part of its nature. If it is isolated upon a pedestal that is too deep and too wide, it will seem lost.

Find the right pedestal proportion. Even build a pedestal (I tend to) expressly for each of your own sculptures and label it with the name of the piece.

I build my larger pedestals with 2″ x 2″ lumber (D-select grade) covered with ½″ Homasote (a brand of fiberboard). I glue the Homasote to the frame with Elmer's glue, and tack it in place. After filling the cracks with Spackle, I paint it with a flat white, black, or neutral housepainter's interior acrylic.

Plywood can also be used. The four sides are cut to proportion, all edges at 45-degree angles, then glued and nailed, using finishing nails which are countersunk and covered with plastic-wood. The top, with its 45-degree edges covered with glue, is dropped into place and then painted in the same fashion.

For the narrower pedestals, I use 1″ x 8″ to 1″ x 12″ kiln-dried Grade A wooden planks which are knot-free.

PLEXIGLAS PEDESTALS

Plexiglas pedestals can be interesting and worth your attention. The transparent kind is especially nice because it moderates the heaviness of the pedestal and allows the sculpture to "float" in the air. It is also possible, of course, to construct pedestals out of opaque and translucent Plexiglas.

The technique is simple. You cut the Plexiglas sheets to size and join the four sides with Plexiglas solvent. The solvent works quickly, and the joint has to be held in position for only a short time.

Auto wax is used to protect the surface and also to cover any scratches the pedestal might pick up. However, there are drawbacks: Plexiglas is easily tipped over because of its light weight,

and it's rather expensive. Yet for some sculpture and in some places, Plexiglas is well worth the cost. Rohm and Haas, Philadelphia, Pennsylvania 19105, makes Plexiglas. The clear (.250″, or ¼″ thick) comes in 30″ x 34″, 36″ x 36″ and 36″ x 48″ sizes. The translucent and opaque types (in .187″, or 3/16″ thickness) come in red, blue, black, and white and are available in 48″ x 72″ sheets.

BACKGROUND

Arthur Miller has said that one of the best tricks he knows to survive as a playwright is to be able—after a play leaves its typewriter and is sent off to producers, etc.—to forget about it completely.

The same is true for the sculptor. Once your work leaves your control, you shouldn't waste your energies worrying about where it stands, how high its pedestal may be, and how it is lighted.

This is especially true about background. You can, as I often do, provide the proper pedestal along with the sculpture and offer lighting suggestions. But it is, perhaps, presumptuous of you to suggest that a wall be repainted or wallpaper changed.

Yet when you have the prerogative, suggest that the background wall be of a modest texture and neutral color: a flat finish paint in grayish tan or white. Fabrics can provide a good background: monk's cloth, certain burlaps, and the natural (easel-painter's) unprimed linens.

Finally, try to have a background that isn't all fancied up with potted plants and inappropriate paintings.

PHOTOGRAPHY

It is often necessary to photograph your sculpture: photographs are needed as parts of resumes, portfolios, records, books, and for publicity in magazines and newspapers.

The 35mm slide is becoming the accepted way of entering shows, rather than by submitting the actual sculpture. Most university art departments now require the submission of color slides as part of their application procedures.

The best idea, I expect, is to entrust the work

English Sailor. Fred Meyer. Courtesy Midtown Galleries, New York. The deep shadows produced by the strong top light emphasize the rough-hewn qualities in a "tough limey."

Charlie Chaplin. Fred Meyer. Collection Mr. and Mrs. F. Richards Ford. I used an emphatic top light here. I cut down on the fill-in light and the kicker to create the effect of the tramp upon the stage. I wanted the photograph to possess a theatrical air.

of photographing your sculpture to a professional. The trouble is that most professional photographers are not, I find, particularly sensitive when photographing sculpture, which is, indeed, very hard to do well.

Most of them never take the sculpture at just the right angle (*my* right angle). Nor do they light it to bring out its best face. The few good photographers of sculpture are busy and hard to pin down. New York City supports a number of photographers who specialize in the photography of sculpture. It is its own art, with its own set of trade secrets. So I do my own photography.

TAKING YOUR OWN PHOTOS

If you decide to photograph your own work, I recommend that you take a night school course in basic and intermediate photography. Here you will learn (or should) the importance of studio lighting. (Don't photograph outdoors; that is much too bucolic.) You will find that the lights used to photograph your sculpture should be arranged much as I have suggested for displaying it.

They include a top light (a strong floodlight), side or "fill-in" lights (medium; with the light on one side heavier than on the other), and a front light or a "kicker" spot for highlights. There should also be a back light to illuminate the background and provide a slight silhouette to set the sculpture forward.

You will learn that a plain background is best. (Unless you find yourself with a venerable instructor who still has a penchant for drapes.) It doesn't help your sculpture at all to have you, your sweetheart, husband, wife, or rubber plant standing beside it.

You will be told to use a respectable camera with a decent lens: a solid tripod and a *cable release* are mandatory. The best lens opening is probably two or three down from the largest f-stop. A single-lens reflex camera is of crucial importance in carefully composing your frame.

An exposure meter is also fundamental. It is a good idea to "bracket" your exposures, taking shots at an f-stop to the right and left of the meter reading stop, as well as the indicated exposure. This helps to vary the color and to insure at least one good negative.

FILMS

There are a number of respectable films: Kodak, Adox, Agfa, Ansco, and Ilford. Should you wish to shoot in color and want *prints* (and live in the U.S.), I recommend you use Ektacolor Professional Type S, a negative stock. This film requires an 80A filter when working under 3200 Kelvin studio lamps and an 80B filter if you work under the 3400 K photoflood lamps.

If you want *slides,* then use Kodak Ektachrome X, a reversal stock, and use an 80A filter once more under 3200 K or an 80B under the 3400 K bulbs.

For black-and-white shooting use Kodak Plus-X Panchromatic. Should you want to photograph in museums (such as the Louvre, the Victoria and Albert, etc.) which have minimal light, use Kodak Tri-X, or Agfa Isopan-Ultra.

DARKROOM

I refuse to go into darkroom procedures, other than to say that entering the darkroom yourself is the only sure way of getting what you want in print. If you are printing black-and-white negatives, I suggest you try the absolutely wonderful Agfa No.5 Brovira. It has the sweetest gray tonality, the pearliest whites, and the deepest true blacks.

When your prints come out of the wash, dry them—provided you've printed on a gloss paper—on polished ferrotype plates (if you want them to be reproduced). Otherwise, for a matt finish, let them soak in print flattener and dry in the open, or put them in a dryer face up under its cloth.

To mount, use dry-mount tissue on cardboard of a respectable ply. Leave an ample margin; use white, gray, or black board. Never mount photographs with Elmer's glue, library paste, or rubber cement.

SHIPPING

Shipping ceramic sculpture is a treacherous business, yet it often has to be done.

Build strong wooden crates and line them with Styrofoam. Wrap the sculpture in foam rubber and tie it with cord. Stuff waddings of newspaper—rather loosely—into the remaining

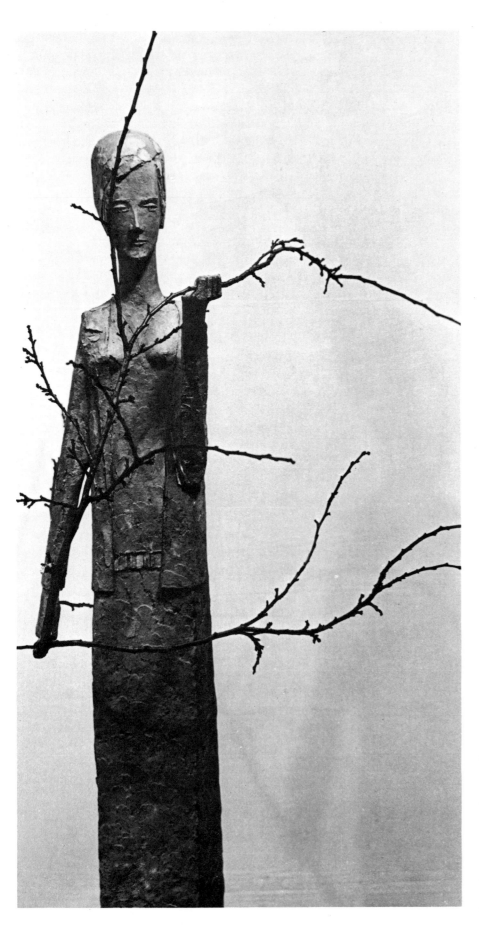

Girl with a Branch. Fred Meyer. *Courtesy Midtown Galleries, New York. Good composition is important. Here, I moved the negative about within the enlarger until I was pleased with the relation of the branches to the paper edge. Later, the print itself was cut, or "cropped," to further improve the break-up of space.*

areas of the crate or pour vermiculite into the space.

Use parcel post or United Parcel Service if your sculpture is very small, otherwise R.E.A. surface or air freight (via Emery, Wings and Wheels, etc.). You can also use such truckers as Eazor, Maislin, Red Star, and North American Van Lines. Be sure that you insure your shipment for breakage.

The shippers are somewhat skeptical when it comes to paying for damaged pieces. There are tales of impoverished sculptors (I expect there are many) packing broken sculpture, in order to be able to enter a claim. The shippers, therefore, question the adequacy of your packing, etc. The shippers also tend to look with dubiousness upon your declared value. They look down at the shards which were once sculpture and say, "Five hundred dollars?" This is when you need to have proof (in the form of gallery sales slips, etc.) that you can command such prices for works of a similar size.

After all is done and your sculpture is on its way, pray.

A Final Word

A book which only deals with examples of ceramic sculpture, provides some information about clays, kilns, workshop, and then shows how a few people work would still be incomplete.

It would have failed to recognize *inspiration*, and without inspiration, all the rest is quite worthless (except as private therapy, perhaps). Oh, there is some point in reproducing exceptional sculpture—people get to *see* it. But how meaningful are the technical chapters if you fail to consider that you must do *more* to produce good sculpture than to know its history and techniques? Too many practitioners work in an ordinary fashion, aping other sculptors and using their techniques in a mechanical way. Work done in a drudging fashion will simply be junk, stuff that would be much better if left undone. Sculpture fashioned in a boring, workaday, banal way will contain those very same qualities.

No, without a doubt, the sculptor must be inspired. And it is not enough, unfortunately, to gird up your loins and *will* inspiration. This sort of grim determination to achieve it often produces results that are more horrendous than those which follow from the rather more indolent way of working.

To create sculpture of significance requires (contrary to fashionable notions) a strict adherence to the fundamentals of craftsmanship. It requires control over the spontaneous impulse, coupled with an intense concentration on the work at hand—the ability to isolate it from all other concerns. What is required is more complicated than the anti-intellectualism of the improvisational found in much of today's art. The sculptor must manage a complete dedication to the power of mind and intellect.

An understanding of beauty is additionally necessary. You must be able to both intuit it in the work of others, and prepare, by certain disciplines, to create it yourself. This is—I really must tell you—devilishly, devilishly hard.

However, it can be accomplished. It is possible to establish criteria to test the worthiness of a piece of sculpture and to establish it as a carrier of that elusive quality, beauty. Beauty is not an arbitrary designation, but a quality specifically inherent within certain objects which makes them works of art. This quality is largely determined by the spirit found within the sculptor himself. The sculptor "in tune" with *essence* —with metaphysical truth—will, often quite automatically, produce a work which captures a hint of such grandeur. Those who view such a work are privileged to know that beauty does exist, factually, and with majesty and force.

Suggested Reading

Ball, Frederick Carlton, *Decorating Pottery with Clay, Slips and Glaze,* Columbus, Ohio: Professional Publications, 1967

Ball, Frederick Carlton, and Lovoos, Janice, *Making Pottery without a Wheel,* New York: Van Nostrand-Reinhold, 1965.

Hetherington, A.L., *Chinese Ceramic Glazes,* Cambridge: Cambridge University Press, 1937.

Leach, Bernard, A *Potter's Book,* New York: Transatlantic Arts, Inc., 1965.

Parmelee, C.W., *Ceramic Glazes,* Boston: Cahners Publishing Co., 1968.

Rewald, John, *Giacomo Manzù,* Greenwich, Connecticut: New York Graphic Society, 1966.

Rhodes, Daniel, *Clay and Glazes for the Potter,* Philadelphia: Chilton Book Co., 1957.

Rhodes, Daniel, *Kilns: Design, Construction, and Operation,* Philadelphia: Chilton Book Co., 1968.

Rhodes, Daniel, *Stoneware and Porcelain,* Philadelphia: Chilton Book Co., 1959.

Selz, Jean, *Modern Sculpture: Origins and Evolution,* New York: George Braziller, Inc., 1963.

List of Suppliers

CLAYS

Edgar Plastic Kaolin Co.
Edgar, Putnam County, Florida 32049

A.P. Green Refractories Co.
1018 East Breckenridge St.
Mexico, Missouri 65265

George Fetzer Co.
1205 17th Ave., Columbus, Ohio 43211

Kentucky-Tennessee Clay Co., Inc.
Box 447, Mayfield, Kentucky 42066

Bell Clay Co.
Gleason, Tennessee 38229

Harris Clay Co.
Box 429, Spruce Pine, North Carolina 28777

Cedar Heights Clay Co.
50 Portsmouth Road, Oak Hill, Ohio 45656

Georgia Kaolin Co.
433 North Broad St.
Elizabeth, New Jersey 07207

KILNS

Pereny Equipment Co., Inc.
Dept. CD, 893 Chambers Road
Columbus, Ohio 43211

Denver Fire Clay, Co.
3033 Blake St., Denver, Colorado 80200

A.D. Alpine Co., Inc.
1837 Teale St.
Culver City, California 90230

CONES

Edward Orton Jr. Ceramic Foundation
1445 Summit St., Columbus, Ohio 43211

OTHER EQUIPMENT

Simpson Mix-Muller Division
National Engineering Co.
Suite 2060, 20 North Wacker St.
Chicago, Illinois 60606

Amaco (American Art Clay Company)
4717 West 16th St.
Indianapolis, Indiana 46222

Patterson-Ludlow Division
Banner Industries Ltd.
1250 Saint George St.
East Liverpool, Ohio 43920

J.C. Steele and Sons Co.
710 South Mulberry St., Drawer 951
Statesville, North Carolina 28677

Jamar Walker Corp., Inc.
365 South 1st Ave.
East Duluth, Minnesota 55802

Ohaus
29 Hanover Road, Florham Park
New Jersey 07932

Brodhead-Garrett Co.
4560 East 71st St.
Cleveland, Ohio 44105

TOOLS

Sculpture House
38 East 30th St., New York, New York 10016

Brodhead-Garrett Co.
4560 East 17th St., Cleveland, Ohio 44105

BRUSHES

Robert Simmons Co.
555 6th Ave., New York, New York 10001

M. Grumbacher, Inc.
460 West 34th St., New York, New York 10001

WAX

Will and Baumer Candle Co., Inc.
Liverpool Road
Syracuse, New York 13200

PLEXIGLAS

Rohm and Haas
Independence Mall West,
Philadelphia, Pennsylvania 19105

Index

Edited by Diane C. Hines
Designed by James Craig and Robert Fillie
Composed in eleven point Journal Roman by JD Computer Type, Inc.
Printed and bound in Japan by Toppan Printing Co., Ltd.